KT-140-587

COURTAULD INSTITUTE GALLERIES

Dennis Farr
William Bradford
Helen Braham

The Courtauld
Institute Galleries

University
of London

SCALA BOOKS

© Courtauld Institute Galleries 1990

First published 1990
by Scala Publications Ltd
3 Greek Street
London W1V 6NX

All rights reserved

ISBN 1 870248 40 6

Photographs: all by A C Cooper & Co, except
Richard Bryant: *View of Somerset House*
Edwin Baker: works of sculpture
© Courtauld Institute Galleries

Designed by Alan Bartram
Edited by Paul Holberton
Produced by Scala Publications
Filmset by August Filmsetting, St Helens, England
Printed and bound by Graphicom, Vicenza, Italy

FRONT COVER
Paul Gauguin, *Nevermore*, 1897 (detail)
BACK COVER
Sir Peter Paul Rubens, *The Family of Jan Brueghel the Elder*,
c1613–15 (detail)

Contents

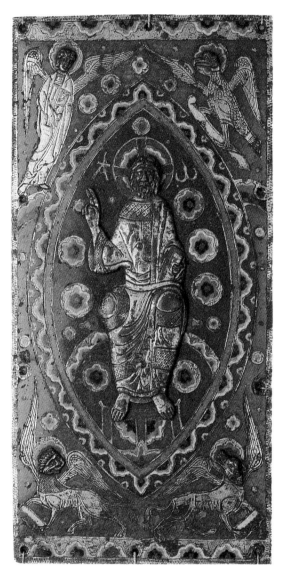

Limoges workshop
c1190 – 1200
Book cover: *Christ with symbols of the*
Evangelists
Gambier-Parry bequest 1966

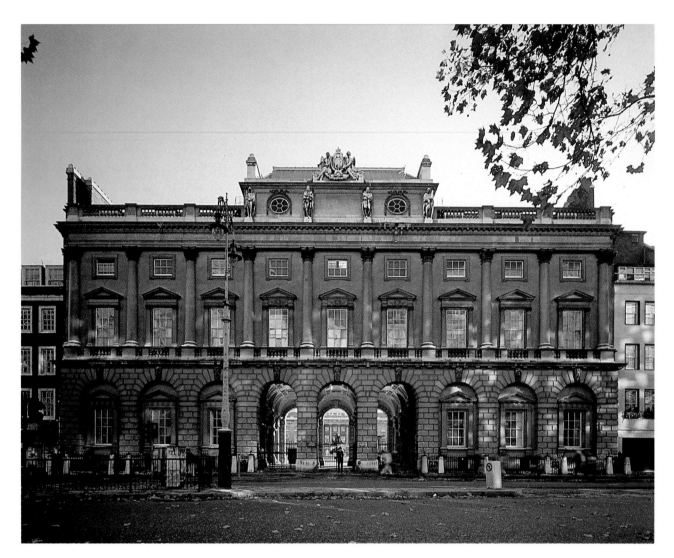

View of Somerset House, 1986

Introduction

The Courtauld Institute Galleries house some ten constituent named collections, of which the most famous are the foundation collection of Impressionist and Post-Impressionist paintings and drawings, and the 'Princes Gate' collection, bequeathed by Count Antoine Seilern as recently as 1978. This superb benefaction rivals in splendour the Samuel Courtauld collection. The Galleries' holdings comprise over 500 paintings, 6000 drawings, and upwards of 26,000 prints, as well as high-quality examples of Italian Renaissance decorative art, Islamic metalwork, Turkish pottery, and a few pieces of sculpture. The range of the collections encompasses twelfth-century Limoges enamels, and medieval ivories; a choice assembly of fourteenth-, fifteenth- and sixteenth-century Italian art; outstanding Flemish and Netherlandish masterpieces, among them a very strong representation of Rubens paintings and drawings; important oil-sketches by Tiepolo; and, of course, all the major Impressionist and Post-Impressionist masters, with an interesting twentieth-century section which includes works by living artists. The several collections, each formed by men and women of taste, discernment and knowledge, complement each other to a remarkable degree. This book celebrates their generosity to an institute which, barely 60 years old, is about to embark on a significant new phase in its history following its removal to Somerset House.

The Courtauld Institute of Art, of which the Courtauld Institute Galleries are an integral part, came into being in 1931 as a result of private munificence and enlightened encouragement by senior members of the University of London at that time. The idea of creating a Senate institute for the teaching of the history of art at undergraduate and postgraduate levels came from Viscount Lee of Fareham (1868-1947), who in 1928 persuaded the then Vice-Chancellor (Sir Gregory Foster) and his professorial colleagues to establish a sub-committee which would report on the academic viability of such a scheme. Lord Lee, who had been a distinguished soldier, diplomat, politician and, eventually, Privy Counsellor, whose wife was American, had been much impressed by the Fogg Art Museum of Harvard University. In 1927 he confided to his wife his wish to see a comparable institute established in London, where art collections of the highest quality were closely linked with an academic institution devoted to art history. He had collected all his life and he and Lady Lee had given their country house, Chequers, with its collection, to the nation in 1917 for the use of the Prime Minister of the day to entertain visiting dignitaries (the gift became effective in January 1921). Almost immediately, he had begun to form a second collection which he subsequently bequeathed to the Courtauld Institute.

By July 1929, the academic bases for the Institute had been agreed, but as yet no endowment found. In the depths of the Depression, this might have seemed a forlorn hope, but Lee approached Samuel Courtauld (1876-1947), chairman of the multinational rayon (artificial silk) manufacturers Courtaulds Ltd, and a passionate, discerning collector of Impressionist and Post-Impressionist paintings since 1922. Courtauld was immediately receptive, and promised substantial financial help (£100,000) with an idea that would fulfil his own desire to spread a knowledge of art more widely. Practical support to both Lee and Courtauld also came from Sir Robert Witt (1872-1952), a lawyer and chairman of the National Art-Collections Fund, who was to bequeath his incomparable photographic archive (of paintings) and collection of

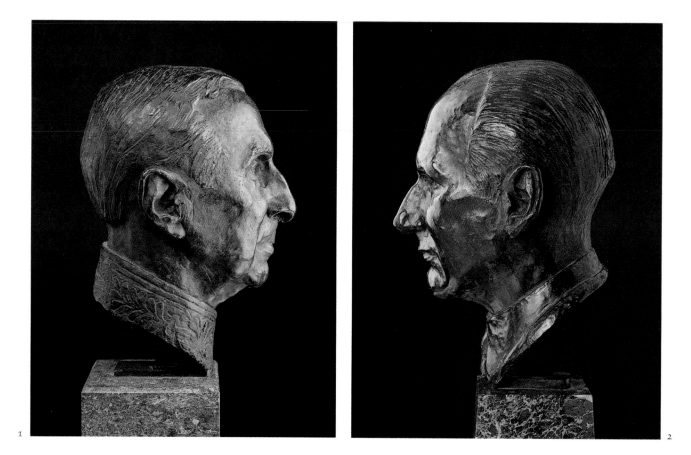

1
Benno Elkan
Dortmund 1887 – 1960 London
Portrait bust of Lord Lee of Fareham,
1944
Bronze, height 35 cm

2
Benno Elkan
Dortmund 1887 – 1960 London
Portrait bust of Samuel Courtauld,
1946
Bronze, height 35.5 cm

Old Master prints and drawings to the Courtauld Institute. As so often happens, once launched, an imaginative project quickly gains more support, and further financial help was given by Sir Joseph Duveen (later Lord Duveen of Millbank), Sir Herbert Cook and Alderman John G Graves of Sheffield, while Sir Martin Conway (later Lord Conway of Allington) presented his photographic archive of architecture, sculpture and the decorative arts. In October 1930 Courtauld's offer had been gratefully accepted and formal approval given by the University to the foundation of the Courtauld Institute of Art. Two years later, in October 1932, the Institute moved from its temporary quarters at 4 Adelphi Terrace to receive its first students at Home House, 20 Portman Square.

The new Institute was welcomed in an editorial in *The Burlington Magazine* of December 1930, with a long letter from Roger Fry (also to be a benefactor) in the same issue warmly supporting its foundation and recalling the early struggles of the founders of that magazine to overcome the 'despondent resignation to the incapacity of England ever to support a journal devoted to the study of art history' in 1903, for 'even among highly placed museum officials this defeatist attitude [was] common'. Fry also alluded to the doubts harboured by some distinguished scholars as to the value of such an institute, for there was widespread suspicion that the history of art was somehow not a respectable academic discipline. Fry, with his own early scientific

training in mind, no doubt, emphasized the importance of a scientific approach to art history. This seems to have been a plea to broaden the scope of study beyond connoisseurship and antiquarian scholarship, which had flourished in England since at least the late seventeenth century. It is intriguing to recall that Sir Charles Eastlake (later Director of the National Gallery) twice refused (in 1833 and 1836) to accept a chair of art offered him by University College, London. Had he accepted, London University would have had a chair of art history well before those created at the Universities of Berlin (1844) and Vienna (1852). Another of Lord Lee's objectives was fulfilled when, in 1934, a Department of Technology was established through the generosity of Sir Percival David and a bequest from Norman Wilkinson of £70,000. Lee realized that the scientific examination of paintings and of their physical structure was essential for their preservation and could also provide information of use to the art historian.

Samuel and Elizabeth Courtauld had lived at 20 Portman Square since 1921, but after the death of his wife in December 1931 Courtauld decided to give the remaining fifty-year lease to the University to house the new Institute. No.20 Portman Square is one of Robert Adam's finest surviving town houses, built 1773-75 for the Dowager Countess of Home, and here were also hung some of the best of Courtauld's collection of Impressionist and Post-Impressionist paintings. Between 1932 and his death in December 1947, Courtauld was to give or bequeath the cream of his collection to the Institute. It was always his intention that Courtauld students, and staff, should enjoy working in close proximity to major works of art as part of their everyday experience.

As more collections were given to the Institute, so the need to build a suite of galleries to house them became increasingly urgent. A site was found in Woburn Square, Bloomsbury, and in October 1958 the Courtauld Institute Galleries were opened on the fifth floor of a new building housing the Warburg Institute below.

When the new Galleries were ready, Lady Lee generously gave up her life interest in the Lee collection and Lord Lee's bequest became effective. In this way a handsome collection of Old Master paintings came to the Courtauld, including such fine works as the Bellini *Assassination of St Peter Martyr*, c1509, Paolo Veronese's *Baptism of Christ*, c1580-88, and the Botticelli *Holy Trinity*, c1491-94. Lee's tastes had become more catholic since forming his first collection, with its emphasis on Flemish and English portraits and on Constable, so as to embrace northern Renaissance art as well as works by Rubens (including the important *Descent from the Cross*), Dobson, Lely, Gainsborough, Romney, Raeburn and Goya. Thomas Gambier Parry (1816-88) had begun collecting as a Cambridge undergraduate, but not until 1849 did he begin to acquire the earlier Italian artists for which his collection is renowned. In that year, he bought Albertinelli's *Creation*, subsequently acquiring a Bernardo Daddi polyptych of 1348 and a Lorenzo Monaco *Coronation of the Virgin* (the central panel of a dismembered altarpiece), as well as three jewel-like predella panels by Fra Angelico. Thomas's grandson, Mark Gambier-Parry, inheriting the collection in 1936, kept it together at much personal sacrifice, and eventually bequeathed it to the Courtauld in 1966. Other benefactions have followed: classical eighteenth- and early nineteenth-century English watercolours from Mr and Mrs William Wycliffe Spooner (1967); a

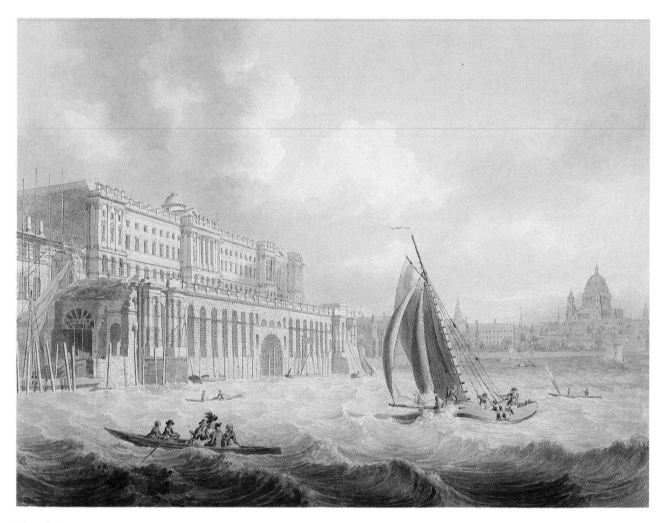

Edward Dayes
London 1763 – 1804 London
Somerset House from the Thames, 1788
Watercolour, 42.7 × 57.5 cm
Spooner collection, s37

set of 13 Turner watercolours from Sir Stephen Courtauld (1974); Dr Alastair Hunter's collection of contemporary British artists (1983); and Lillian Browse's choice collection of late nineteenth-century and twentieth-century French and English works, in which she retains a life interest.

The plan to construct a new building for the Institute next to the Galleries never came to fruition. Instead, negotiations between the University and the Department of the Environment were begun in 1979 with the intention of moving both Institute and Galleries into the North Block of Somerset House in The Strand, to meet their joint need for not only much more space, but also more coherently integrated accommodation. Originally the Fine Rooms in the North Block of Sir William Chambers's grand design of 1775 housed the three learned societies, The Royal Society, The Society of Antiquaries, and the Royal Academy of Arts, but the North Block, completed in 1780, was part of a much bigger scheme to house government departments, and by the mid-1850s the Royal Academy and the learned societies had left for larger accommodation (in Burlington House and Carlton House Terrace, where they remain to this day). The Registrar-General's office was housed in part of the vacated space. The Courtauld Institute of Art moved into its new quarters in the summer and early autumn of 1989; the Galleries occupied the Fine Rooms in spring 1990, opening to the public on 15 June 1990.

DENNIS FARR
Director
Courtauld Institute Galleries

Italian and Northern Renaissance

The Courtauld's holdings of fourteenth- and fifteenth-century art are limited, but contain important and delightful images.

In the Italian Schools, the earliest pictures are two works by Bernardo Daddi. Daddi's triptych inscribed 1338 belongs to the middle of the artist's career, and offers an exquisite example of the type of portable tabernacle made for private patrons. Its scale and intimacy contrast directly with his last signed and dated work, the grand polyptych painted for San Giorgio a Rubella, Florence, in 1348. From the 1340s, too, comes the *Nativity* by the Master of the Gambier-Parry Nativity, one of the finest and earliest of the Riminese masters, to whom *Scenes from the Life of Christ* in Berlin and Venice have also been attributed. Datable to the second half of the fourteenth century are two panels by artists whose styles are rooted in the Byzantine tradition. Paolo Veneziano's *Virgin and Child* possibly formed part of a triptych similar to one in Parma, with whose central panel it closely compares; while Barnaba da Modena's signed *Virgin and Child* is one of several variants, of which the closest, in Frankfurt and Turin, are dated 1367 and 1370 respectively. The century ends with Lorenzo Monaco's *Coronation of the Virgin*, the pinnacle and most important remaining element of a large triptych which once decorated the high altar of San Gaggio, Florence. Datable c1394-95, it is one of Lorenzo's earliest surviving works.

The fifteenth century begins with paintings by Fra Angelico, whose style derives from Lorenzo Monaco's. The three panels of the *Imago pietatis* and flanking *Saints* are works of Angelico's early maturity, and once formed the predella for the altarpiece *The Virgin and Child with Dominican saints* (Museo di San Marco, Florence) painted for the Dominican nuns of San Pietro Martire, Florence, in 1429. Almost contemporary with the Fra Angelico are the fine *Annunciation* by a Florentine master; the panels depicting the story of Sts Julitta and Quiricus by an anonymous Tuscan artist; and the illuminated letter 'E' by a Milanese artist working in the manner of Michelino da Besozzo and Giovannino de' Grassi.

Representing the phase of Venetian painting before the dominance of Giovanni Bellini is Antonio Vivarini's intensely coloured *Birth of St Augustine*. This, together with panels in Bergamo, Detroit and (previously) London, once formed part of the St Monica altar painted c1440-50 for Santo Stefano, Venice. The *St Sebastian* by the Bolognese Marco Zoppo was painted in Venice, at the later date of c1475-78, and shows this artist's somewhat harsh, Mantegnesque manner tempered by the example of Antonello da Messina's style.

The course of Venetian painting was transformed by Giovanni Bellini, who, during his long career, reinterpreted Mantegna's linear vision into a concept of space apprehended through light and the harmonious relation of tonal values. This new, atmospheric perspective is seen in the *Assassination of St Peter Martyr* ascribed to Bellini, and is also expressed through the broken penwork of one of the master's few extant drawings, *The Nativity*. Both Giovanni and Gentile Bellini's draughtsmanship clearly influenced that of Carpaccio, as his drawing *The Virgin reading to the infant Christ* demonstrates.

Among the most impressive examples of art produced in Florence in the later fifteenth century are the Morelli-Nerli *cassoni* of 1472, and Perugino's serene *Virgin and Child*, painted shortly after 1483. The major work here representing the final decade is undoubtedly the *Holy Trinity* by Botticelli and assistants, painted probably for the convent of Sant'Elisabetta delle Convertite, Florence. Also Albertinelli's *Creation*, although painted c1513-15, is justifiably placed in the context of the fifteenth century. Probably a *cassone* panel, it shares with similar paintings the outmoded convention of combining different scenes from a single narrative, set against a continuous landscape. The landscape here is, however, particularly charming.

Of distinguished fourteenth- and fifteenth-century pictures other than Italian, the earliest is the Estouteville triptych attributable to a Flemish artist working in c1360-75. The triptych of *The Entombment* of c1420, in which boldly patterned draperies suggest an oriental setting, is perhaps the earliest extant work of the Master of Flémalle, probably identifiable with Robert Campin, the leading painter at Tournai. Exceptional among fifteenth-century drawings for its spontaneous assurance is Hugo van der Goes's *St Ursula*. Perhaps a study for a lost *Virgin and Child with saints*, it is among the most influential images of its day. Works from the final decades of the fifteenth century include the portrait of Jan de Mol painted by the little-known Master of the Guild of St George at Malines, possibly as early as 1485; the portrait of Dr Johann Wespach by an Ulm master; and the magnificent *Head of a saint* by a singular late-Gothic artist who worked mainly in Cologne, the Master of the Altar of St Bartholomew.

Bernardo Daddi
active in Florence; died 1348
Triptych, central panel: *The Virgin and Child enthroned with saints* (above: *God in benediction*); left: *The Nativity*; right: *The Crucifixion* (above left and right: *The Four Evangelists; the Annunciation*), 1338

Tempera, gold-leaf on panel, integral frame, central panel 87.5 × 42.5 cm; left panel 63.6 × 17.5 cm; right panel 62.7 × 18.7 cm
Seilern bequest 1978, CIG 81A, 81B, 81C

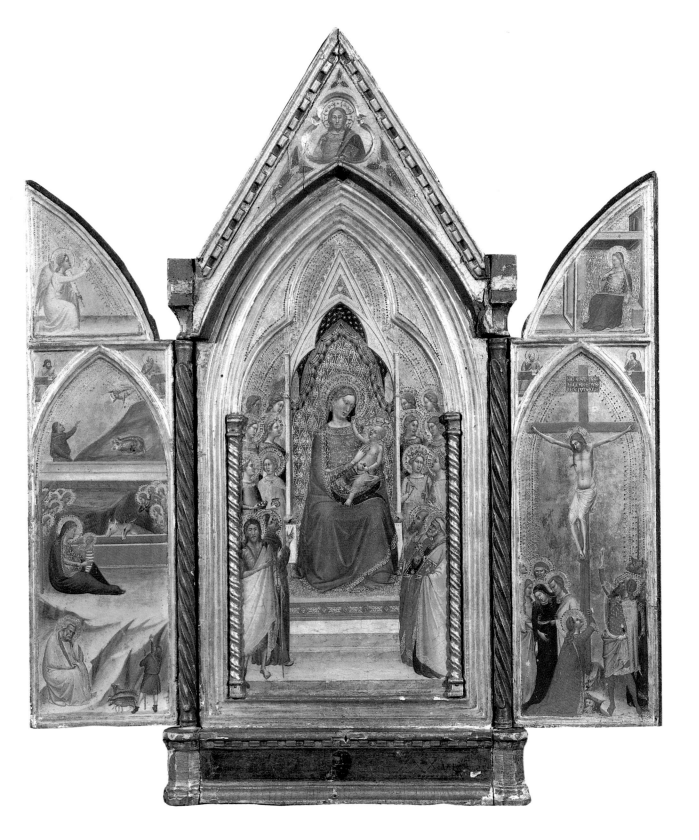

1

Barnaba da Modena
active from 1362; died 1383 Genoa
The Virgin and Child
Tempera, gold-leaf on panel,
26.5 × 19.1 cm
Lee bequest 1947, CIG 20

2

Paolo Veneziano
active Venice 1333 – 1362
The Virgin and Child (above: *The Crucifixion*)
Tempera, gold-leaf on panel, integral frame, 112.7 × 46.1 cm
Lee bequest 1947, CIG 307

1

2

Lorenzo Monaco
Siena? c1370 – c1429 Florence
The Coronation of the Virgin (above:
Christ in benediction), c1394-95
Tempera, gold-leaf on panel, integral
frame, 195 × 154.7 cm
Gambier-Parry bequest 1966, CIG 272

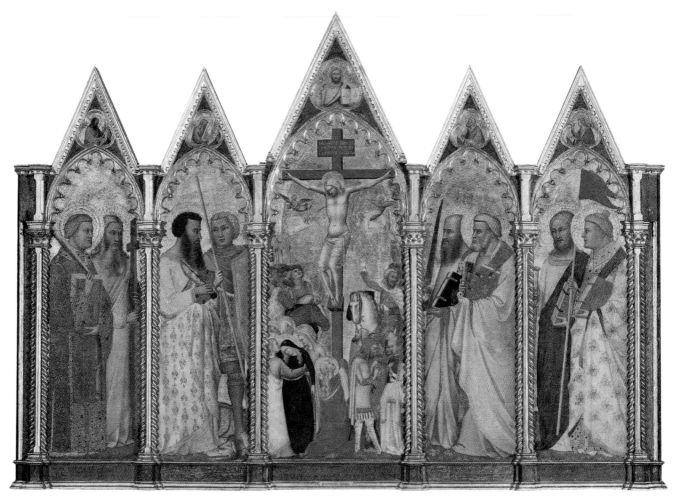

1

1 and 2
Bernardo Daddi
active in Florence; died 1348
The Crucifixion with saints, 1348
Polyptych,
centre panel 155.8 × 52.4 cm;
left panel 138.2 × 82.8 cm;
right panel 138.3 × 82.5 cm
Gambier-Parry bequest 1966, CIG 82A,
82B, 82C, 82D, 82E

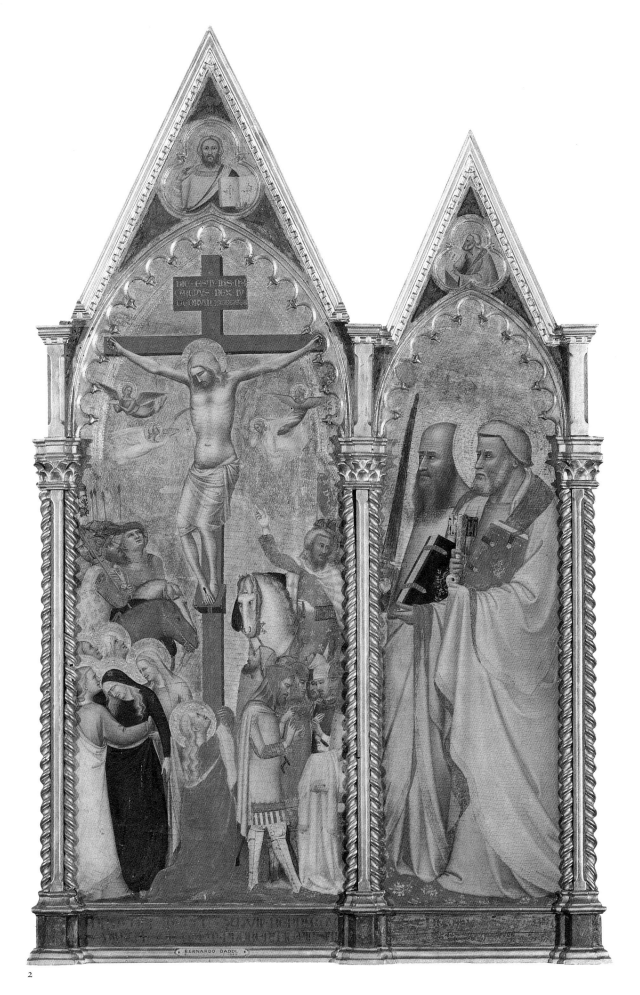

BERNARDO DADDI

2

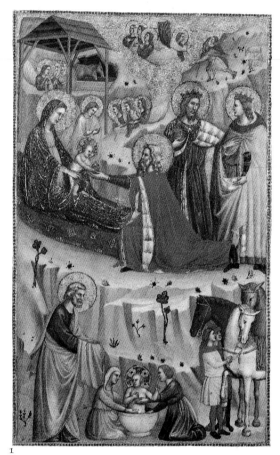

1

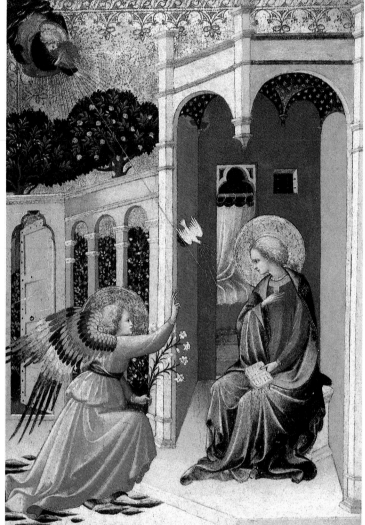

2

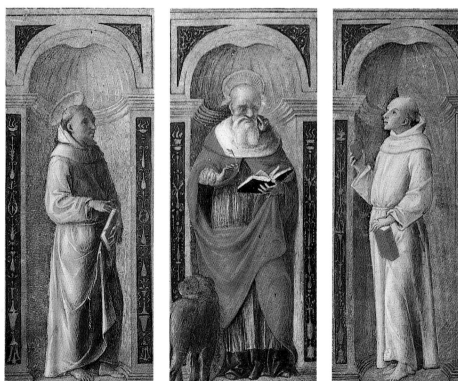

3

1
Master of the Gambier-Parry Nativity
active in Rimini 1st half 14th century
The Nativity and the Adoration of the Magi
Tempera, gold-leaf on panel,
45.5 × 27.8 cm
Gambier-Parry bequest 1966, CIG 255

2
Florentine School
15th century
The Annunciation, c1430
Tempera, gold-leaf on panel,
54.2 × 37.6 cm
Gambier-Parry bequest 1966, CIG 126

3
Attributed to Giacomo Pacchiarotto
Siena 1474 – 1540 Viterbo?
St Francis; St Jerome; St Anthony of Padua
Tempera, gold-leaf on panel
Three panels, each panel 29 × 12 cm
Gambier-Parry bequest 1966, CIG 304

4
Fra Angelico
Vicchio di Mugello *c*1400? – 1455 Rome
The dead Christ and saints
Tempera, gold-leaf on panel;
centre panel 20.5 × 54.8 cm;
left panel 20.2 × 49.3 cm;
right panel 20.5 × 50.9 cm
Gambier-Parry bequest 1966, CIG 10A, 10B, 10C

5
Milanese School
Early 15th century
Decorated initial 'E'
Bodycolour on vellum, 14.7 × 14.7
Gambier-Parry bequest 1966

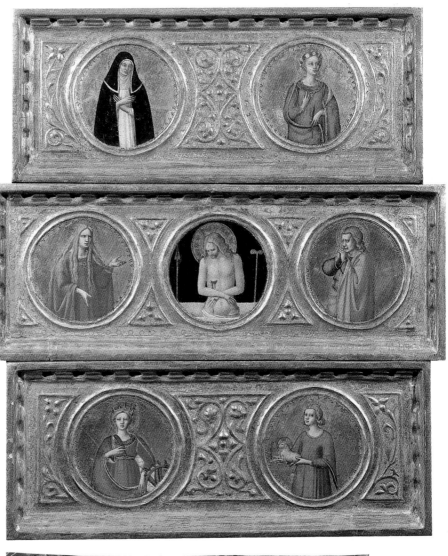

4

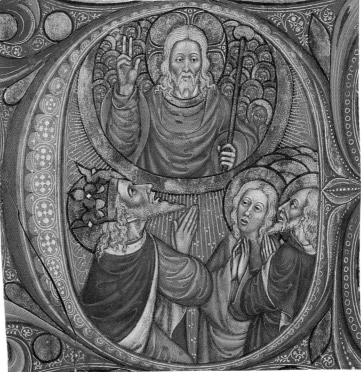

5

19

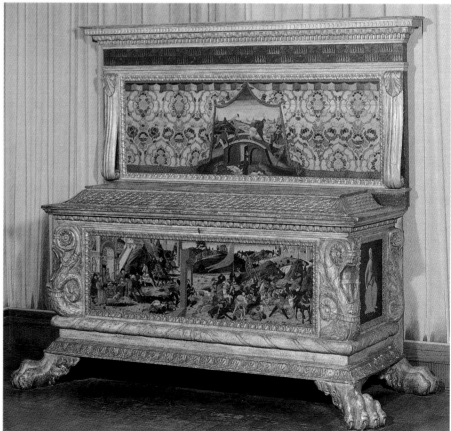

1

1 and 2

Zanobi di Domenico, Jacopo del Sellaio, Biagio d'Antonio active in Florence in 1472

The Morelli *cassone*, 1472

Overall size (including *spalliera*)

212 × 193 × 76.2 cm

Lee bequest 1947

The *cassoni* (chests for household linen), complete with original *spalliere* (vertical back pieces) were commissioned by Lorenzo di Matteo di Morelli on the occasion of his marriage to Vaggia di Tanai di Francesco Nerli in 1472. Zanobi di Domenico carved the *cassone* carcasses, Jacopo del Sellaio and Biagio d'Antonio painted the decorative scenes. Each chest displays the arms of the Morelli and Nerli families at its corners. The *spalliere* and fronts are decorated with scenes from Books II and V of Livy's *Histories*, the sides with paired *Virtues*. Justice and Fortitude — masculine virtues — complement the stories of Horatius Cocles defending the bridge (on the *spalliera*) and Camillus defeating the Gauls on the front.

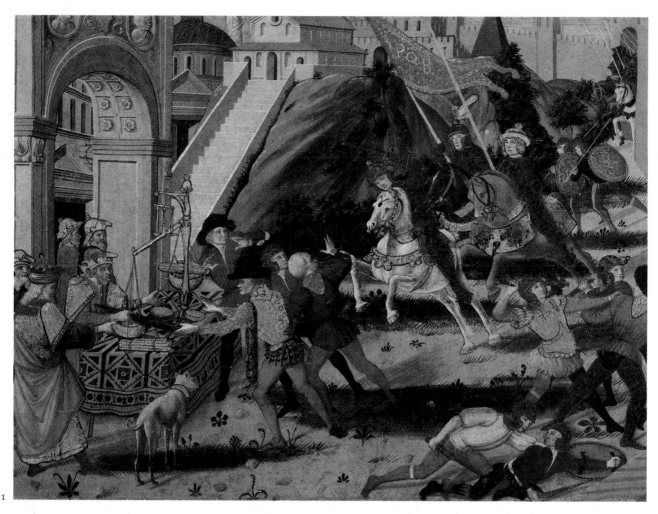

2

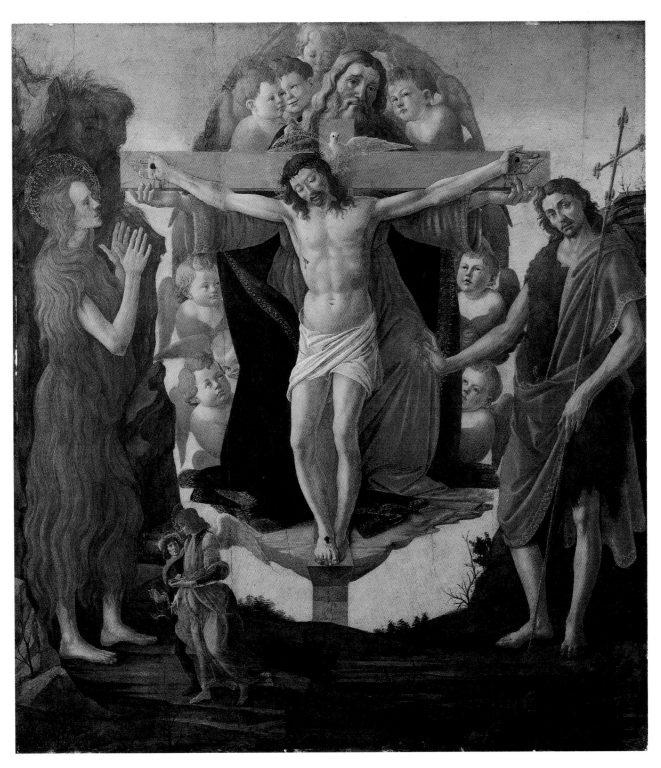

Sandro Botticelli
Florence 1444/5 – 1510 Florence
The Holy Trinity with St John the Baptist,
Mary Magdalene, Tobias and the Angel,
c1490-95
Tempera on panel, 214 × 192.4 cm
Lee bequest 1947, CIG 38
Almost certainly the main panel of the
high altar of the Augustinian convent
of Sant'Elisabetta delle Convertite,
Florence, this passionate and tragic
composition was painted by Botticelli

and assistants between 1491 and
1494. The panel's present condition
makes it difficult to determine the
degree of workshop participation,
although it is accepted that the grand
design is the master's. The Convertite
convent was founded in 1329 to
house reformed prostitutes, which
explains the prominence, at the right
of the Trinity, of the Magdalen. Her
legend is also the subject of the
altarpiece's predella in the John G

Johnson Collection, Philadelphia. The
penitent Magdalen, together with
John the Baptist, patron saint of
Florence, who looks towards the
viewer from the composition's left,
occupy an appropriately barren, rocky
landscape, in the left foreground of
which also appear the small-scale fig-
ures of Tobias and the Angel. These
may allude to the apprenticing of the
Convertite's illegitimate children.

21

1

**Master of the Lathrop Tondo
active in Lucca 1506 – 1525**
The Adoration of the Magi
Panel, 21.6 × 52.2 cm
Gambier-Parry bequest, CIG 259

2

**Attributed to Pietro Perugino
Città della Pieve *c*1445/6 –
1523 Fontignano**
The Virgin and Child, after 1483
Tempera on panel, painted surface
77.3 × 56 cm
Gambier-Parry bequest 1966, CIG 312

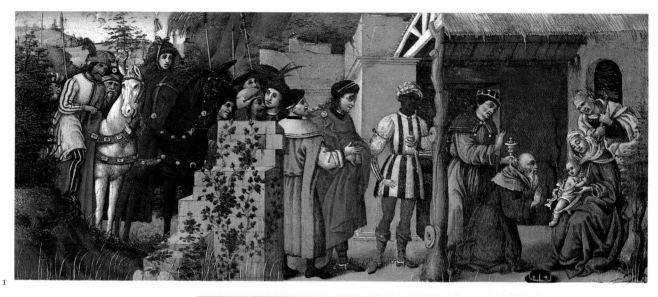

1

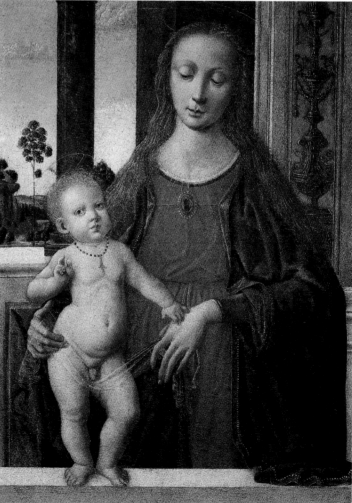

2

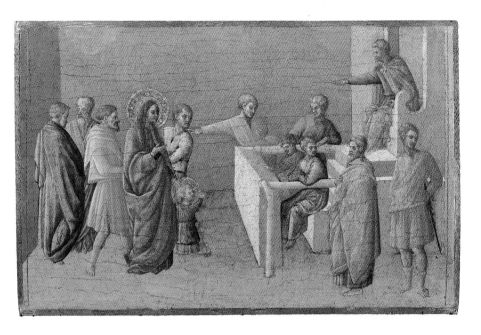

3
**Master of St Julitta and St Quiricus
active 1430s in Tuscany**
*Sts Julitta and Quiricus accused of
embracing Christianity; St Quiricus slaps
the judge; Martyrdom of the saints*
Tempera and gold-leaf on panel; three
predella panels, 29.4 × 46.5 cm,
25 × 28.3 cm, 29.3 × 48.7 cm
Gambier-Parry bequest 1966,
CIG 264A, 264B, 264C

These panels are among the very few
representations in Italian Renaissance
art of the story of the martyrs Julitta
and Quiricus. Fleeing persecution of
the Christians in Lycaonia, the noble-
woman Julitta and her three-year-old
son Quiricus arrived at Tarsus, there
to discover similar persecution under
the governor, Alexander. Brought to
trial, Julitta, echoed by Quiricus, reaf-
firmed her Christian faith and was
condemned to be racked and
scourged. Thinking to pacify her son,
Alexander took him upon his knee,
whereupon the child scratched and
slapped his face. Enraged, Alexander
dashed him to the ground, killing him.

The Master who is named after
these panels has been defined as a
Tuscan – but possibly not Florentine –
follower of Masaccio, active in the
1430s. To him also have been attri-
buted a *Madonna and saints* in the
Scaglietti collection, Bologna, and an
Esther in the temple in the John G John-
son Collection, Philadelphia.

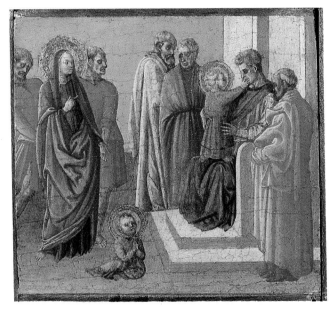

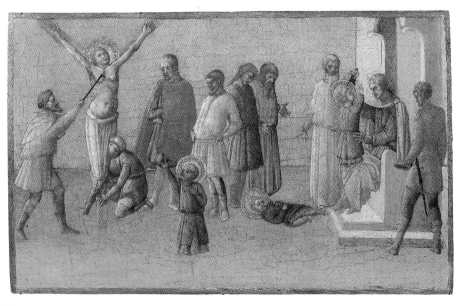

3

1
Antonio Vivarini
Murano *c***1415 – 1476/84 Venice**
The birth of St Augustine, c1440-50
Tempera on panel, 32.7 × 25.3 cm
Lee bequest 1948, CIG 480

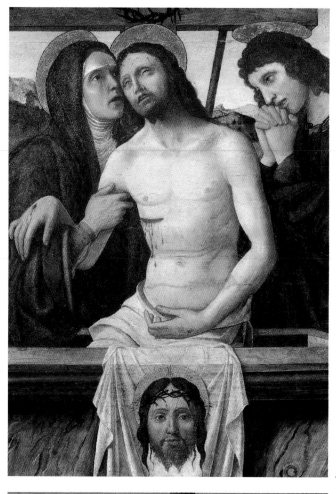

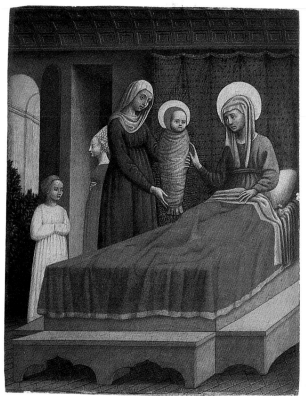

1

2
Attributed to Gian Francesco de'
Maineri
born Parma; active 1489 – 1506 in
Mantua and Ferrara
Lamentation over the dead Christ
Tempera on panel, 58.8 × 42.6 cm
Lee bequest 1947, CIG 231

3
Marco Zoppo
Bologna 1432 – 1478 Venice
St Sebastian in a rocky landscape with Sts
Jerome, Anthony Abbot and Christopher,
c1475-78
Panel, 41.9 × 31.4 cm
Seilern bequest 1978, CIG 489

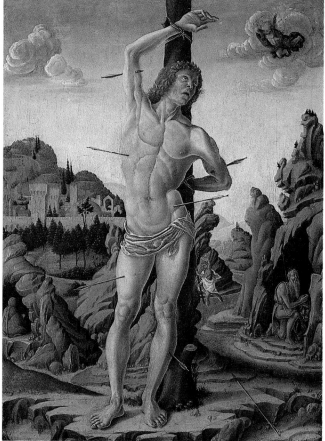

2

3

4 and 5
Mariotto Albertinelli
Florence 1474 – 1515 Florence
The Creation and Fall, c1513-15
Oil on panel, 56.4 × 165.4 cm
Gambier-Parry bequest 1966, CIG 6

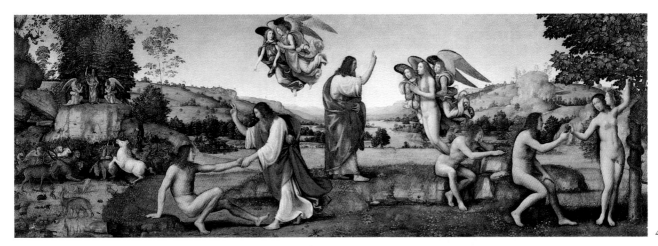

4

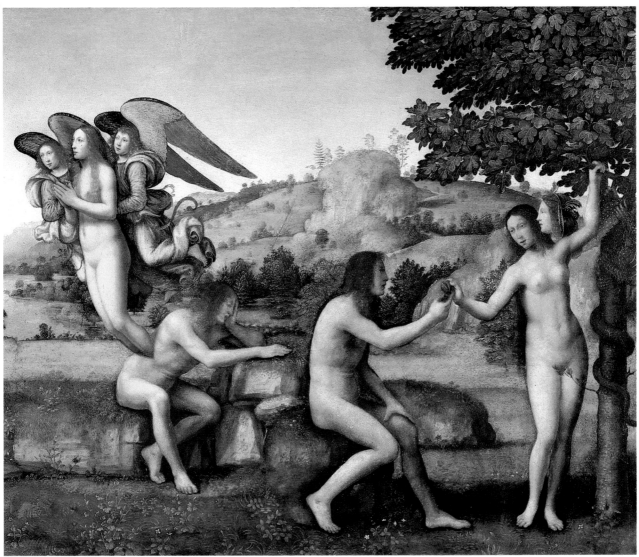

5

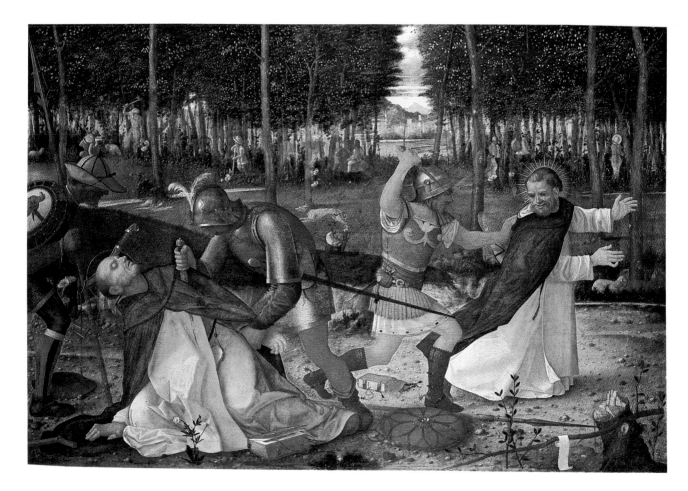

Giovanni Bellini
Venice *c*1430 – 1516 Venice
The assassination of St Peter Martyr
Oil on panel, 68.1 × 100 cm
Lee bequest 1947, CIG 29

The *Golden Legend* tells the story of
the Dominican St Peter and a compan-
ion, who in 1252 were ambushed
between Como and Milan by assas-
sins hired by local heretics. Felled by
an axe blow to the head, the saint was
despatched by a dagger through the
body. Dying, he reaffirmed his Chris-
tian beliefs by writing on the ground
with his blood 'credo'. In this picture,

the saint's slaughter is paralleled by
the action of background woodmen
cutting down trees which bleed in
sympathy. The panel, said to have
been dated on the back 1509, is
ascribed to Bellini since it closely
resembles a picture of the same sub-
ject attributed to him in the National
Gallery, London. Absent from that
version, however, is the soldier seen
here on the left, whose heraldic shield
and dress may provide clues to the
identity of the patron who com-
missioned the picture.

1

2

1
Giovanni Bellini
Venice c1430 – 1516 Venice
The Nativity
Pen and iron gall ink on thin buff laid
paper, 20.1 × 21.2 cm (maximum
extension)
Seilern bequest 1978

2
Vittore Carpaccio
Venice c1460/5 – 1525/6 Venice
The Virgin reading to the infant Christ
Pen and ink over red chalk,
12.8 × 9.4 cm
Seilern bequest 1978

27

1

Flemish school?
14th century
The Estouteville triptych: left panel:
Infancy of Christ; centre panel:
Crucifixion and other Passion scenes;
right panel: *Ascension, Pentecost and
the Death of the Virgin, c1360-75*
Tempera, gold-leaf on panel, integral
frame; centre 83.1 × 56.3 cm; left
83 × 28 cm; right 83 × 27.8 cm
Lee bequest 1947, CIG 109A, 109B,
109C

2

Workshop of the Boucicault Master
active in Paris *c*1400 – 20
Page from a Book of Hours: *Shepherds,
c1415-20*
Vellum, *c*18 × 13 cm
Gambier-Parry bequest 1966

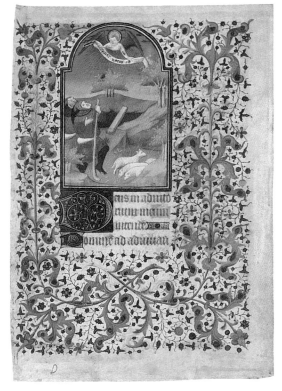

2

?**Robert Campin**
? *c*1375 – 1444 Tournai
Triptych: left panel: *The Two Thieves*;
centre: *the Entombment*; right: *the
Resurrection*, *c*1420
Panel, integral frame, centre panel
65.2 × 53.6 cm, wings 64.9 × 26.8 cm
Seilern bequest 1978, CIG 253A, 253B,
253C

Little is known of the history, and
nothing of the commission of this
work, still in its original integral frame
with folding shutters. It was probably
painted as a domestic devotional pic-
ture for the unknown donor, who is
depicted kneeling on the left. In the
background the two thieves still hang
upon their crosses; a ladder leans

against the empty cross from which
Christ's body has been taken to the
tomb in the centre. The Virgin, sup-
ported by St John, leans to kiss her
Son while Joseph of Arimathea and
Nicodemus support the body; chief
among the other Holy Women, Mary
Magdalen anoints the feet. Grieving
angels hold the Instruments of the

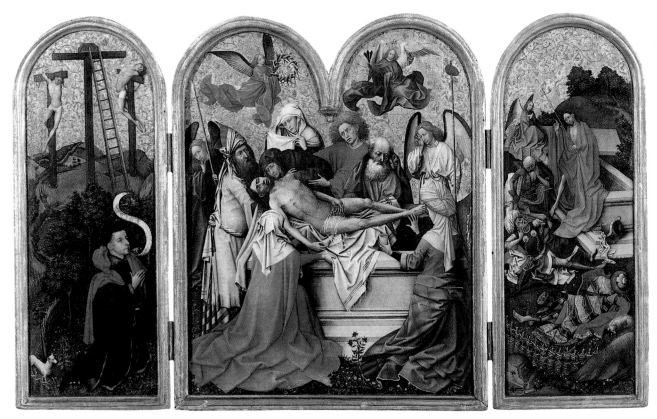

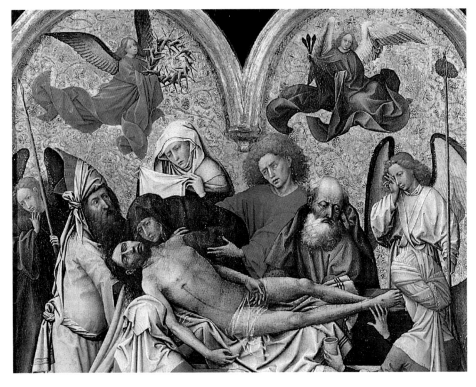

Passion, one glancing compassionately
back at the donor. The wattle fence on
the right continues into the right
wing, where the resurrected Christ
steps from the tomb. In place of the
sky, gold leaf covers raised plant pat-
terns, the grapes in the centre panel
signifying the Eucharist, the Sacra-
ment through which the donor can
hope for eternal life promised by
Christ's resurrection.

The style indicates that this is the
earliest surviving work, about 1420, of
the so-called Master of Flémalle, prob-
ably Robert Campin; this is therefore
one of the first paintings of the early
Netherlandish school and its first mas-
terpiece. The artist probably used oil
as medium, like his contemporary, Jan
van Eyck, and this enabled him to
achieve a new subtlety and richness
which, joined to the striking realism,
makes this one of the most celebrated
works in the Collection.

1

Master of Ulm
active *c*I500
Dr Johann Wespach, 1500
Panel, 38.8 × 30.5 cm
Lee bequest 1947, CIG 257

2

Master of the Guild of St George at Malines
active 1485 – 1505
Jan de Mol, c1490-98
Panel, integral frame, picture surface
29.9 × 17.7 cm
Lee bequest 1947, CIG 257

3

Master of the Altar of St Bartholomew
active 1470 – 1510
Head of a saint against a landscape
(fragment), *c1495-1500*
Panel, 14.6 × 15.1 cm
Sir Robert Witt bequest 1952, CIG 247

1

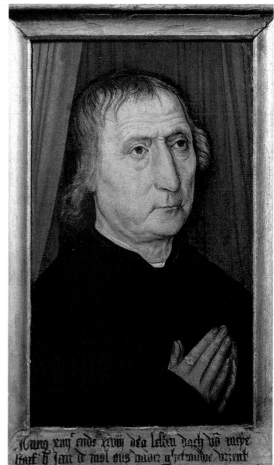

2

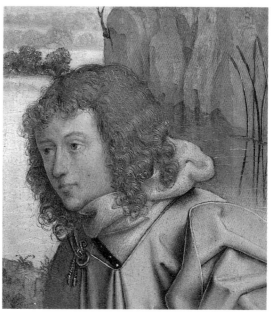

3

Hugo van der Goes
active Ghent 1467; died 1482 near
Brussels
Female saint
Pen and ink or watercolour wash,
heightening in white bodycolour, on
off-white laid paper, 23 × 18.9 cm
Seilern bequest 1978

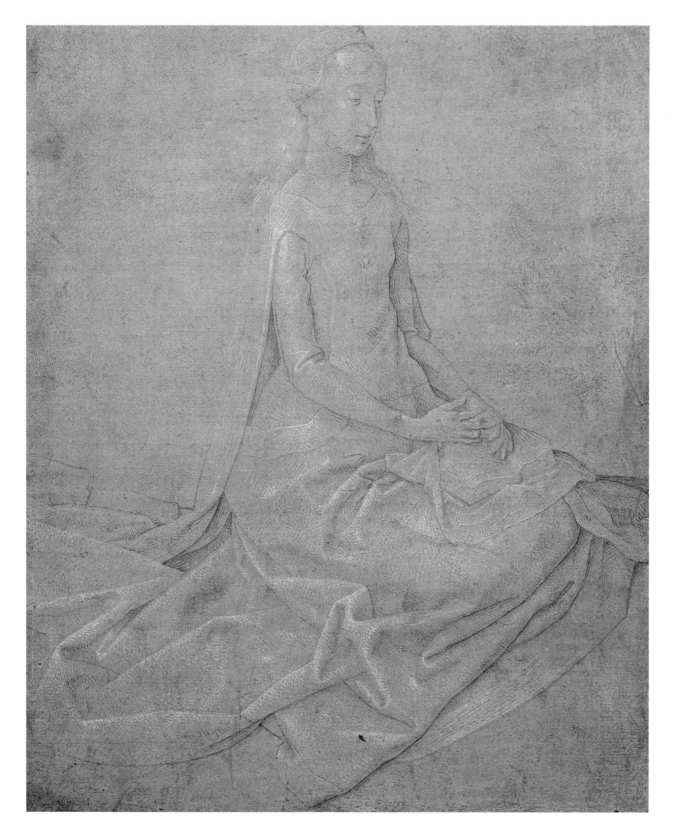

High Renaissance

The sixteenth century is introduced by a group of magnificent drawings from the Seilern collection, among the earliest of which is Fra Bartolommeo's *View of Florence from the Valle de Mugnone*, one of the first examples of pure landscape drawing. Then follow two sheets by the most powerful and complete personality of the century, Michelangelo. The enigmatic *Dream of Human Life*, possibly a presentation piece, dates from the second half of 1533 or later, and is drawn in a stippled manner which imitates the surface of polished marble. The *Christ on the Cross*, one of a group of similar subjects dating from Michelangelo's last years, offers an image of intense suffering which emerges from, and is quickened by, a web of searching lines. Somewhat earlier than these compositions is Pontormo's monumental and disquieting study of a seated studio assistant.

Among works by artists influenced by the clarity and strength of Raphael's style are the *Incredulity of St Thomas* of the early 1530s by Polidoro da Caravaggio and the *Holy Family*, an unfinished work of considerable technical interest now generally ascribed to Perino del Vaga. The *Holy Family* by the Ferrarese Garofalo, who adopted elements of Raphael's style when in Rome, is a mature rendering of a theme this artist treated many times, and is datable to the late 1530s. Garofalo's influence is seen in his contemporary and compatriot L'Ortolano's panel *The Woman taken in Adultery* (in its saturated colour and the handling of the figures on the left).

Comparison between Parmigianino's small-scale *Holy Family* of 1523 and the *Virgin and Child* of 1524-27 reveals the artist's move away from a Correggio-inspired treatment towards a weightier manner in which are fused stylistic elements derived from Raphael and Michelangelo. Indeed, Michelangelo's *Erythraean Sibyl* on the ceiling of the Sistine Chapel probably provided the inspiration for the pose of the Virgin in the later panel. To Parmigianino's early mentor, Correggio, is assigned a portrait of a man, the model for which may have also posed for the figure at the right of Correggio's *Martyrdom of four saints* in Parma.

The portrait drawing of a young man by Lotto is among the earliest of the sixteenth-century Venetian works in the Courtauld. Of the period *c*1508-10, it relates to Lotto's early painted portraits. In his Titianesque canvas *The Holy Family* dated 1535(?) Lotto repeats the grouping of the Virgin and Child and Anne from his painting of the previous year, *The Virgin and Child with Sts Anne, Joachim and Jerome* (Uffizi, Florence). Palma Vecchio, a native of Bergamo, settled early in Venice. His *Venus in a landscape* of *c*1520 is one of a group of similar compositions, closest to which is a canvas in the Norton Simon collection, California.

The final two Venetian works were executed in the last half of the century. From the later 1570s dates Jacopo and Domenico Tintoretto's *Adoration of the Shepherds*, the composition and lighting of which recalls the artist's painting on the same theme in the Upper Hall of the Scuola di San Rocco, Venice. Paolo Veronese's *Baptism of Christ*, probably a *modello* for an altarpiece, is generally considered to be a late painting because of its affinities with the *Baptism* in the Redentore, Venice, a work completed by the artist's heirs.

The section devoted to northern art opens with Cranach's *Adam and Eve*, signed and dated 1526. Based upon Dürer's celebrated engraving of 1504, this freely painted work is less portentous than its German precedent. Perhaps destined for a wealthy collector, its intention is to give pleasure rather than instruction.

Of the remaining painters represented here, the majority trained or practiced in Antwerp. Earliest of these is Quinten Massys, whose *Crucifixion* dates from the beginning of his career in the 1490s. Characterized by dramatic oppositions of light and shadow, this work is in marked contrast to the delicate *Madonna standing with the Child and angels* of 1500-09. Here, the illumination is brighter, more diffuse, and Massys introduces into the composition putti, garlands and swags, elements derived from North Italian Quattrocento painting. The Italianate, sculptural figure style of Mabuse is seen in his *Virgin and Child*, one of the most distinguished of some eight versions of this composition known.

Memorable northern portraits include that of an unknown (Netherlandish?) lady, dated 1536, by the Master A.W., and the eccentric, allegorical representation of Sir John Luttrell by Hans Eworth (Ewouts), who moved from Antwerp to England in 1545/49.

The genius of sixteenth-century Flemish art, Pieter Bruegel the Elder, is represented by two works. The vigorous drawing of 1559, which depicts the Whitsuntide Festival of Longbowmen at Hoboken, describes all the boisterous activity of a village on holiday. In the contrastingly lyrical painting dated 1563, Bruegel adheres to the *Weltlandschaft* convention of the previous century, so that the figures, although significant, are dominated by the handsome panorama.

Polidoro da Caravaggio
Caravaggio 1492 – 1543 Messina
The Incredulity of St Thomas, c1531-35
Panel, 203 × 125.7 cm
Seilern bequest 1978, CIG 326

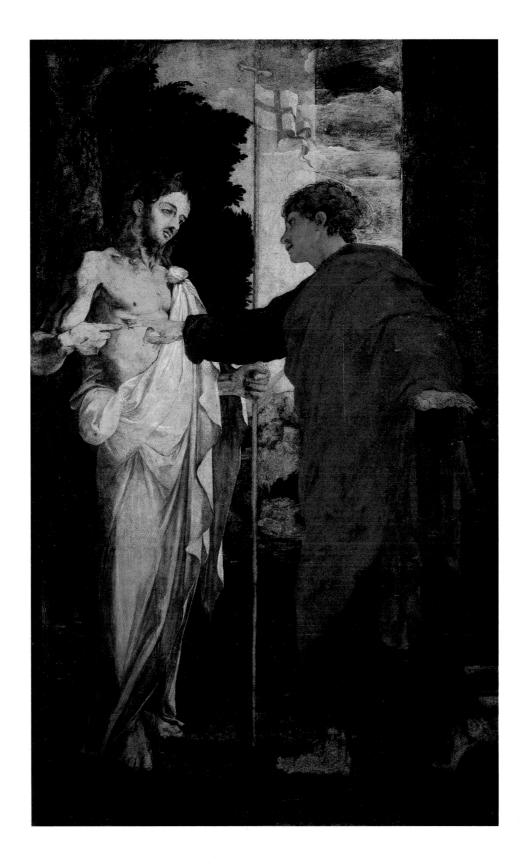

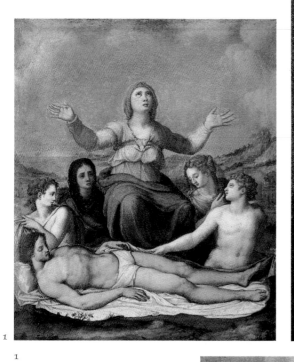

1

Attributed to Alessandro Allori
Florence 1535 – 1607 Florence
Pietà
Lead alloy, 23 × 20 cm
Lee bequest 1947, CIG 8

2

Attributed to Antonio Allegri
called Correggio
Correggio 1489/94 –
1534 Correggio
Portrait of a man
Canvas, painted surface
52.8 × 42.2 cm
Courtauld bequest 1948, CIG 72

3

Francesco Mazzola called
Parmigianino
Parma 1503 – 1540 Casalmaggiore
The Holy Family, c1522-24
Panel, painted surface 43.1 × 47.3 cm
Seilern bequest 1978, CIG 308

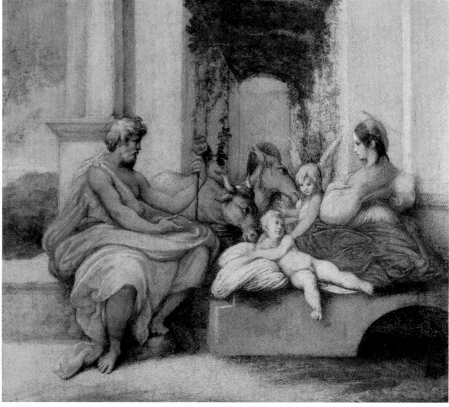

3

34

4

Francesco Mazzola called
Parmigianino
Parma 1503 – 1540 Casalmaggiore
The Virgin and Child, c1525-27
Panel, painted surface 63.5 × 50.7 cm
Seilern bequest 1978, CIG 309

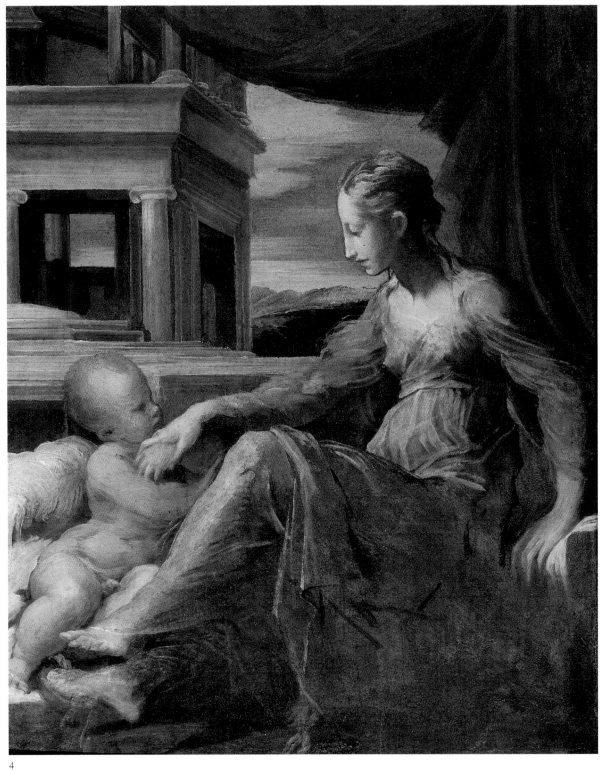

4

1

Attributed to Perino del Vaga
Florence 1501 – 1547 Rome
The Holy Family
Panel, 106.6 × 77.6 cm
Presented by the National Art-
Collections Fund 1932, CIG 311

2

Benvenuto Tisi called Garofalo
Ferrara 1481 – 1559 Ferrara
The Holy Family with the infant St John
and St Elizabeth
Panel, 47.5 × 32.1 cm
Gambier-Parry bequest 1966, CIG 161

3

Benvenuto Tisi called Garofalo
Ferrara 1481 – 1559 Ferrara
The Adoration of the Shepherds
Panel, 40.2 × 28.1 cm
Gambier-Parry bequest 1966, CIG 160

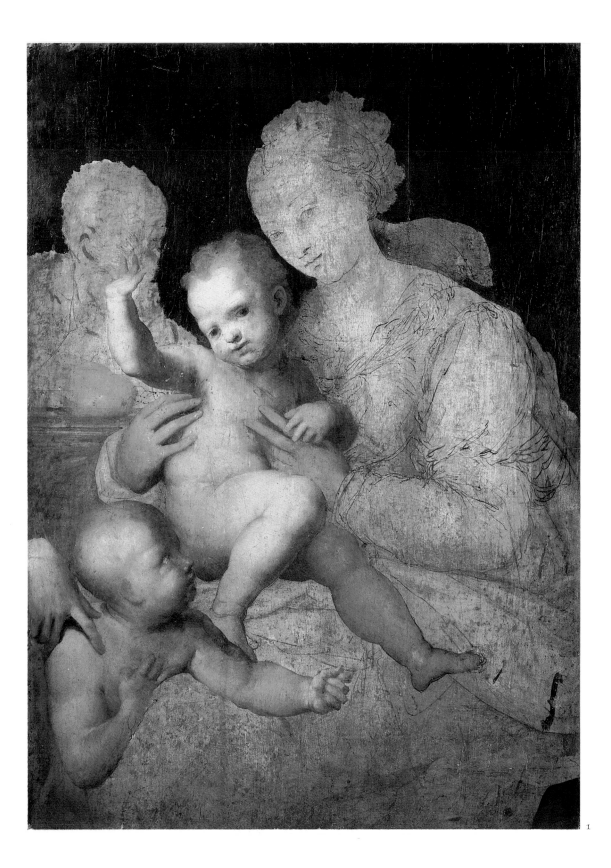

1

1

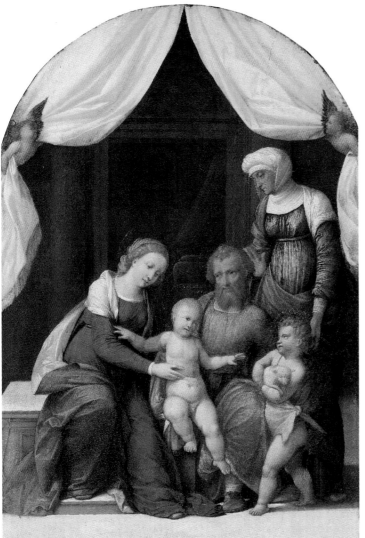

4

Giovanni Battista Benvenuti called l'Ortolano

Ferrara *c*1487 – 1527 Ferrara

The Woman taken in Adultery

Panel, 71.2 × 87.3 cm

Lee bequest 1947, CIG 301

2

3

4

1
Jacopo Palma il Vecchio
Serina *c*1480 – 1528 Venice
Venus in a landscape, c1520
Canvas, 77.5 × 152.7 cm
Seilern bequest 1978, CIG 305

2
Lorenzo Lotto
Venice *c*1480 – 1556 Loreto
The Holy Family with St Anne, 1535?
Canvas, painted surface 61 × 79 cm
Seilern bequest 1978, CIG 224

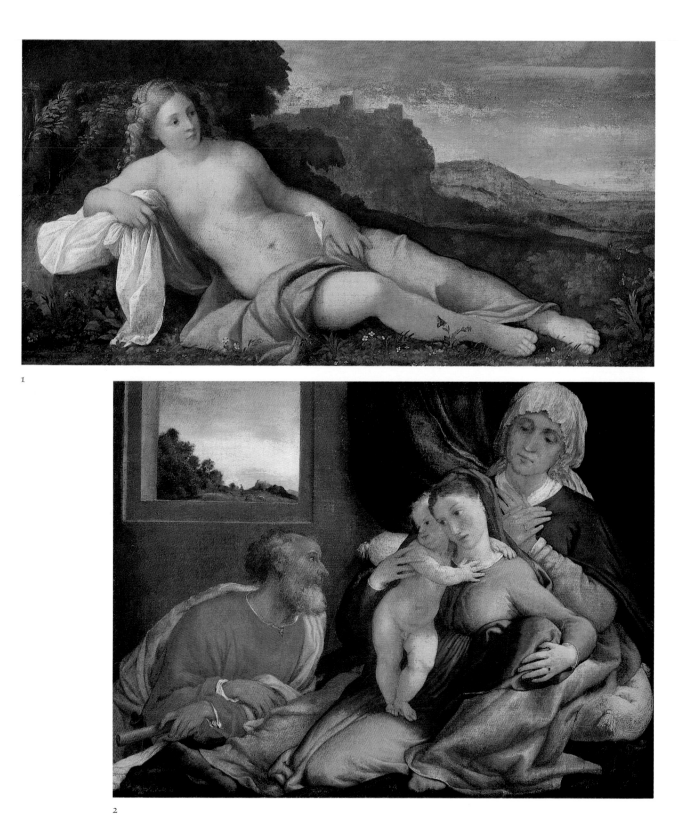

1

2

Jacopo and Domenico Tintoretto
Venice 1518 – 1594 Venice; Venice
1560 – 1635 Venice
The Adoration of the Shepherds, c1578
Canvas, painted surface 76 × 86.8 cm
Seilern bequest 1978, CIG 460

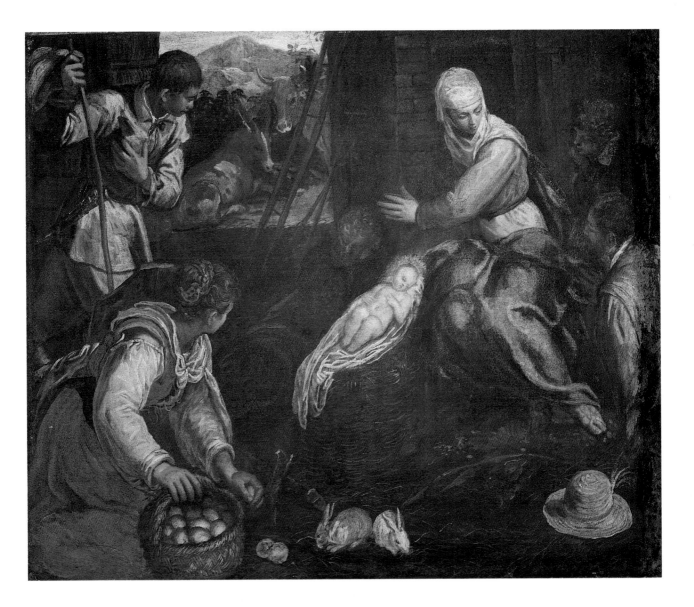

1
Jacopo Carucci called Pontormo
Pontormo 1494 – 1557 Florence
Seated youth, c1525
Black chalk on pale buff laid paper,
40.5 × 28 cm
Seilern bequest 1978

2
Lorenzo Lotto
Venice c1480 – 1556 Loreto
Portrait of a young man, c1508-10
Black chalk on white laid paper
prepared with green watercolour,
33.5 × 26.9 cm
Seilern bequest 1978

3
Baccio della Porta called Fra
Bartolommeo
Florence 1472 – 1517 Pian di Mugnone
View of Florence from the Valle del
Mugnone?, c1504-15
Pen and iron-gall ink on paper,
20.5 × 29.1 cm
Seilern bequest 1978

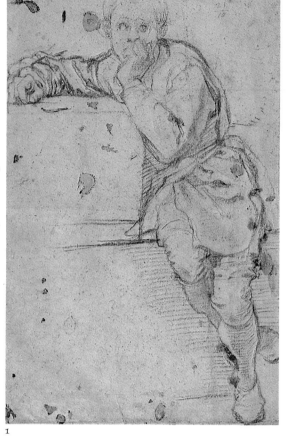

1

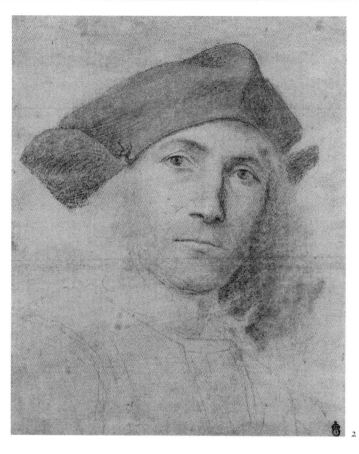

2

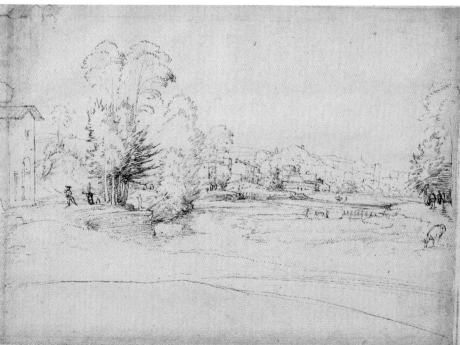

3

Very few landscape drawings by Fra Bartolommeo were known until the discovery in 1957 of an album, among the earliest surviving pure landscape drawings in European art. The leaves are now scattered but by far the largest group, ten drawings on seven sheets, is in the Seilern collection. Most of the 41 drawings from the album are, like this, in pen and iron gall ink and make use of similar graphic formulae.

The outstanding precedent is a pen-and-ink study of the Arno made in 1473 by Leonardo, by whom Fra Bartolommeo was much influenced. These drawings are neither real views nor imaginative creations, but a mixture of both.

Paolo Veronese
Verona 1528 – 1588 Venice
The Baptism of Christ, c1580-88
Canvas, 54.8 × 45.6 cm
Lee bequest 1947, CIG 476

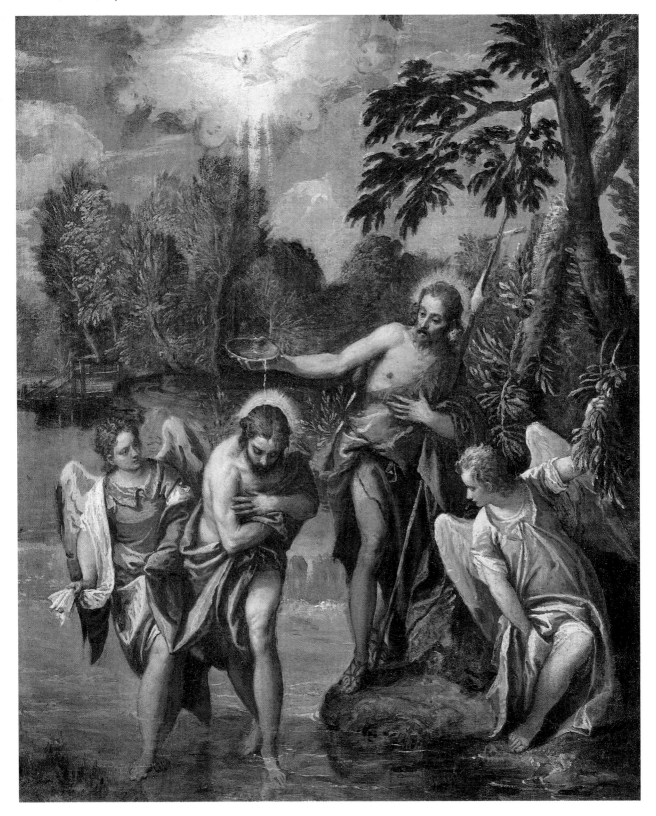

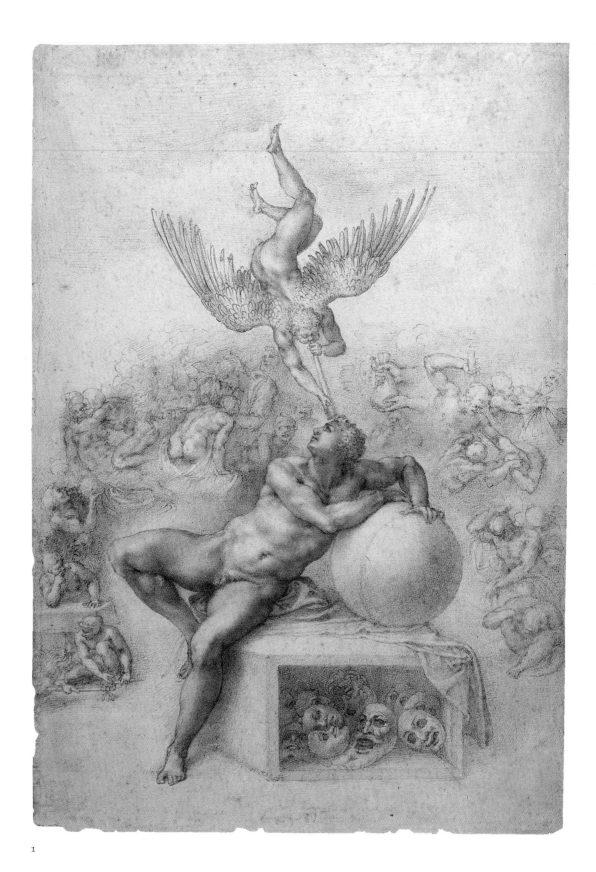

1

Michelangelo Buonarroti
Caprese 1475 – 1564 Rome
'The dream of human life'
Black chalk on paper, 39.6 × 28 cm
Seilern bequest

This celebrated work belongs to the group of so-called 'presentation drawings', in highly finished chalk technique and of religious or allegorical subjects, made by Michelangelo as gifts for close friends. Tommaso de' Cavalieri, a young Roman nobleman, was one of these, known to have received several comparable pagan narrative drawings of about 1533, and possibly the recipient of this one also. Its subsequent distinguished history included ownership by Sir Thomas Lawrence.

The title derives from Vasari's description of the drawing in 1568 as 'il sogno', the dream; no better contemporary interpretation exists. The principal, heroically nude figure, grasping the globe, reclines on a box containing masks, which signify illusions; behind him six of the Seven Deadly Sins are ranged in an arc, Gluttony and Lechery on the left, Avarice, Wrath, Envy and Sloth on the right. Pride is absent, perhaps because it encompasses them all. The winged figure may be Fame or an angel, blowing a trumpet to rouse Man from sinful dreams to the higher spheres of celestial virtue.

If the status of this sheet as an original were doubted, the artist's own corrections (notably the feet of Fame) provide proof. It is indeed technically astounding and can only be autograph. As in others of the kind, there is deliberate diversity of technique between less well defined background and the central subject so finished as to emulate, perhaps consciously, a polished gem. The stippled effect is accomplished by minute strokes of the black chalk, the blank areas of the coarse paper providing highlights. His friends are known to have examined Michelangelo's drawings of this kind with the aid of a magnifying glass.

Michelangelo Buonarroti
Caprese 1475 – 1564 Rome
Christ on the Cross, c1560-64
Black chalk on white laid paper,
27.5 × 23.4 cm
Seilern bequest 1978

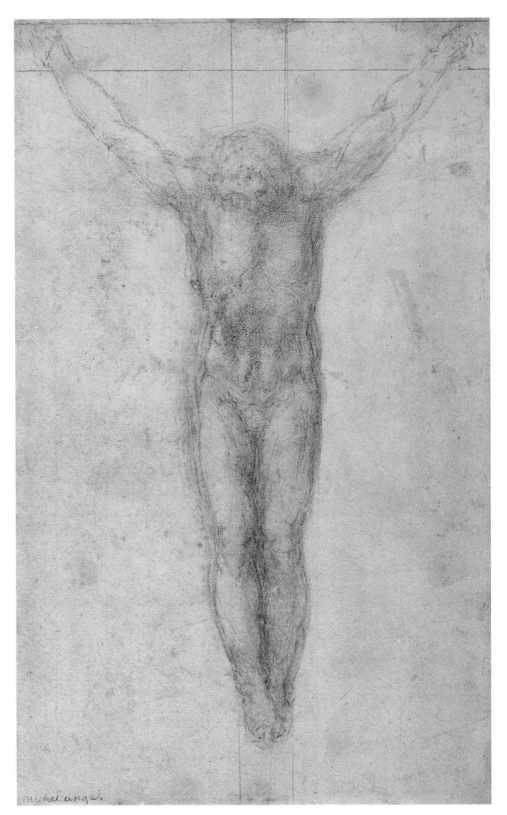

2

Quinten Massys
Louvain 1466 – 1530 Antwerp
The Madonna standing with the Child
and angels, c1500-09
Panel, painted surface 48.5 × 32.8 cm
Seilern bequest 1978, CIG 245

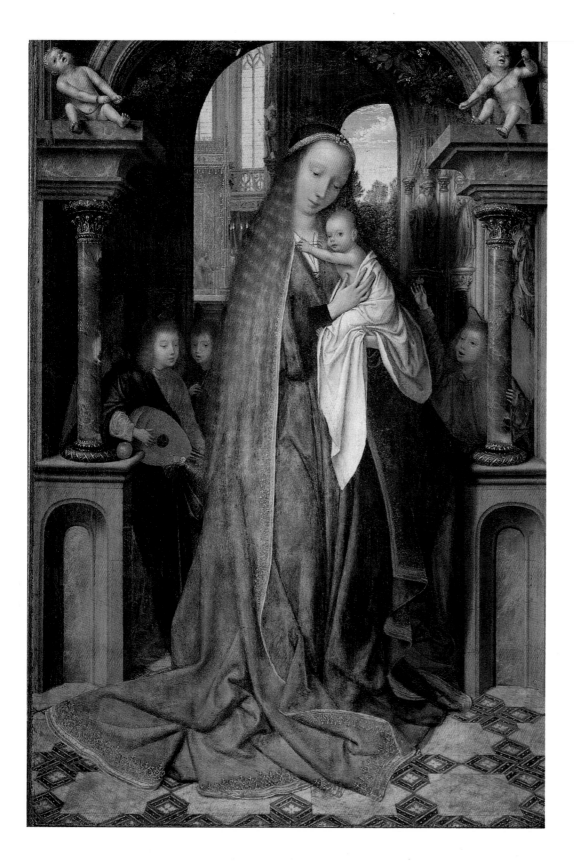

Lucas Cranach the Elder
Kronach 1472 – 1553 Weimar
Adam and Eve, 1526
Panel, 117 × 80 cm
Lee bequest 1947, CIG 77

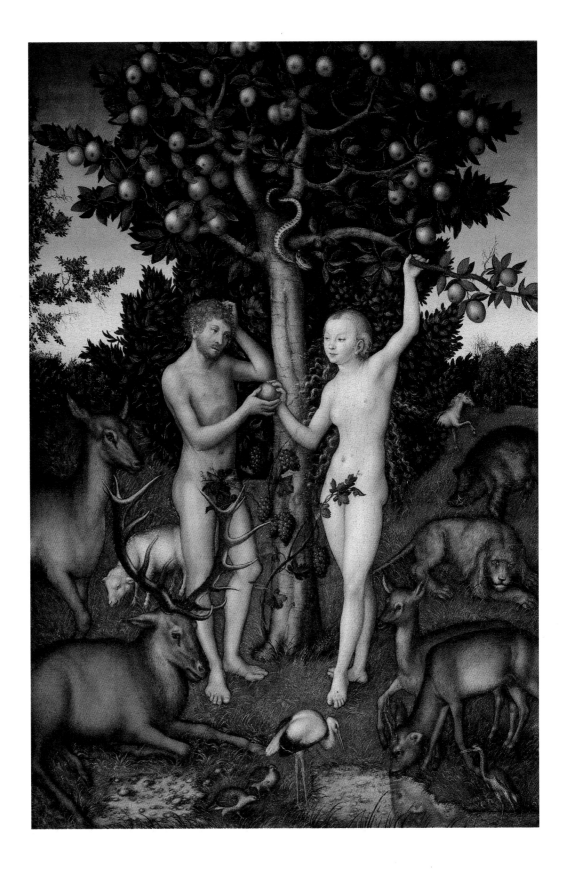

1
Jörg Breu the Elder
Augsburg *c*1480 – 1537 Augsburg
Portrait of a man, 1533
Panel, 67.8 × 49.2 cm
Lee bequest 1947, CIG 46

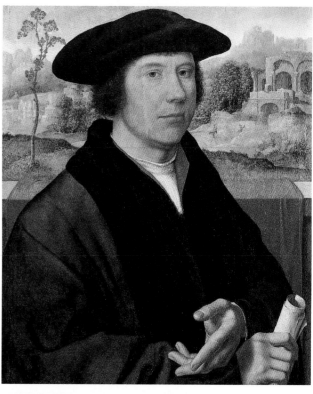

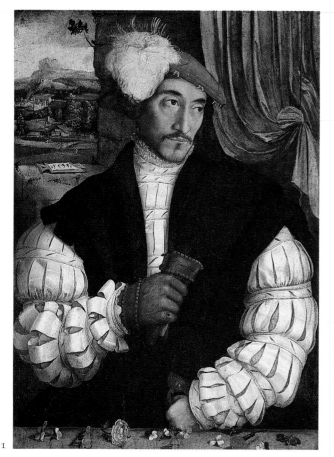

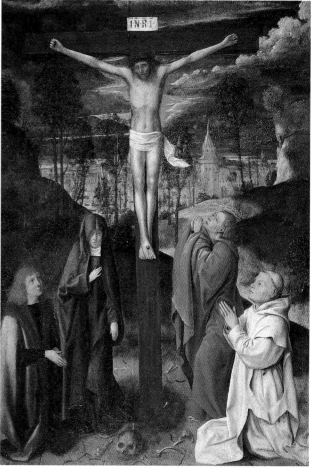

2
Attributed to Joos van Cleve
Active 1511 – 41 in Antwerp
Portrait of a man
Panel, 47.8 × 39.9 cm
Lee bequest 1947, CIG 65

3
Quinten Massys
Louvain 1466 – 1530 Antwerp
Christ on the Cross between the Virgin, St
John and two donors, c1490-95
Panel, painted surface 50.3 × 34.4 cm
Seilern bequest 1978, CIG 244

Master A.W.
active 1st half 16th century
Portrait of a lady, 1536
Panel, 77.1 × 60.5 cm
Lee bequest 1947, CIG 246

47

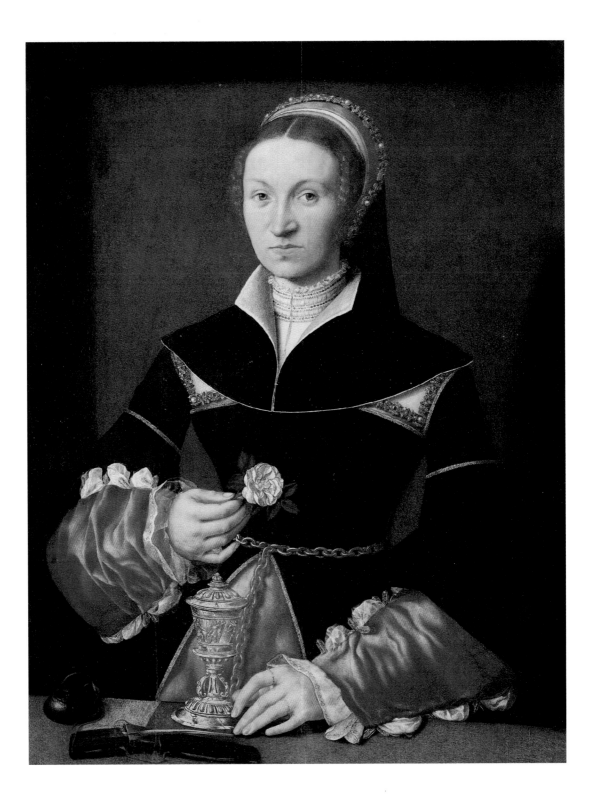

1

Jan Gossaert called Mabuse
Maubert *c*1478 – 1533 Middlebourg
The Virgin and Child
Panel, 43.5 × 33 cm
Lee bequest, CIG 229

2

Hans Eworth
Antwerp *c*1520 – 1574 London
Allegorical portrait of Sir John
Luttrell, 1550
Panel, 109.3 × 83.8 cm
Lee bequest 1947, CIG 119

3

Pieter Breugel the Elder
Breda? *c*1525/30 – 1569 Brussels
Landscape with the Flight into Egypt,
1563
Panel, 37.1 × 55.6 cm
Seilern bequest 1978, CIG 47

4

Pieter Bruegel the Elder
Breda? *c*1525/30 – 1569 Brussels
Kermesse at Hoboken, 1559
Black chalk, pen and iron gall ink on
pale buff laid paper, 26.5 × 39.4 cm
Lee bequest 1947

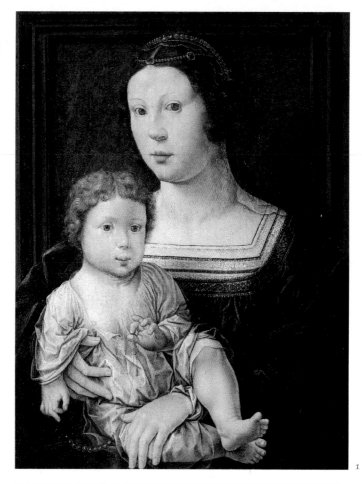

1

2

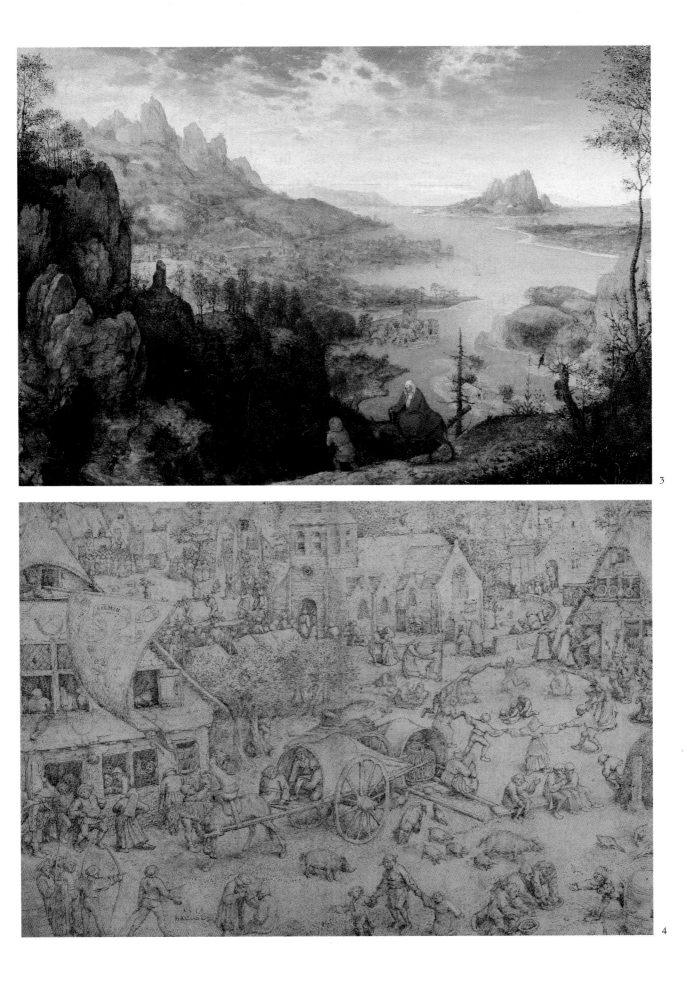

3

4

The Baroque

The seventeenth-century holdings of the Courtauld Galleries are dominated by a superb group of works by Rubens. It consists of 33 paintings and more than 20 drawings: it is one of the outstanding Rubens collections of the world, and was, with one notable exception, put together by Count Antoine Seilern, chiefly between the 1930s and 1950s. Before his bequest, the Lee collection already held the oil-sketch for the central panel of his celebrated *Descent from the Cross* altarpiece in Antwerp, and to this were added those from Count Seilern's collection for the wings. Another remarkable ensemble of oil-sketches is the group of five for Rubens's ceiling, now destroyed, of the Jesuit church in Antwerp, of which *Esther before Ahasuerus* is a sparkling example. *The Bounty of James I* is a sketch for a comparable decorative scheme, but one which survives in London, the ceiling of the Banqueting House in Whitehall, while *The death of Achilles* is one of a pair of paintings from a series of eight scenes of the hero's life, made in preparation for a set of tapestries.

The prime single works by Rubens in the collection must be his *Family of Jan Brueghel the Elder*, with its lively and appealing portraits of the children of Rubens's friend and fellow-artist, and the famous *Landscape by moonlight* painted in the last years of his life, a magical view which foreshadows the work of the English landscape painters by whom it was to be known and appreciated generations later. *The Entombment*, like the oil-sketches for the Antwerp altarpiece, is moving witness to Rubens's devoutly held Catholic faith. The two drawings illustrated here are, by contrast, evidence of the frank enjoyment of the female form with which his name is popularly associated: *The bath of Diana*, a late work, shows him under the beneficent influence of his mentor, Titian, and the portrait of his second wife, *Helena Fourment*, is a monument to his domestic felicity as well as to the power and delicacy of his draughtsmanship.

Rubens's most brilliant assistant, Anthony van Dyck, is represented by prominent works from his precocious youth, much influenced by the older artist: the *Man in an armchair* is an early example of his portraiture, the genre at which he excelled. Steenwyck was also an Antwerp artist, and one whose meticulous paintings such as *St Jerome in his study* were, like the very

different art of Rubens and van Dyck, much admired by Charles I. How a picture gallery of a well-to-do collector might appear in the seventeenth century can be seen in the *Picture gallery of Pieter Stevens(?)* begun by Frans Francken the Younger and completed by David Teniers the Younger.

While the Spanish Netherlands is well represented, there are scarcely any paintings here from Holland; there is, however, an outstanding collection of Rembrandt's drawings, again from the Seilern collection: among the finest are the *Seated actor* and the evocative little *View of Diemen*.

Another important group of drawings, acquired this time by Sir Robert Witt, comprises some 40 sheets by the Bolognese artist Guercino: among these, the fine *Aurora* is a preparatory drawing for his frescoed masterpiece in Rome. Of the Italian paintings, those produced early in the century in Mantua and Venice by Domenico Fetti are of outstanding quality; the liveliness of his *Adam and Eve at work* and the enchanting *Vertumnus and Pomona* contrast with the smoothness of the *Virgin in Prayer* by the later Sassoferrato, whose nostalgic 'Raphaelism' and piety once commanded the highest regard, notably among English collectors. Forabosco's attributed portrait of a man displays the confidence typical of Baroque portraiture, and Pietro da Cortona's *Faith, Hope and Charity* hints at the richness achieved by that master of Roman Baroque decorative painting. The influence of Italy is paramount in the French works in the collections – in Blanchard's *Charity* (a favourite subject with him) and Claude's exquisite *Landscape with an imaginary view of Tivoli*, apparently the smallest of all his paintings.

Portraiture was one of the chief glories of art in seventeenth-century England. The native William Dobson's striking double portrait, *An old and a younger man*, of the early 1640s, was painted perhaps to commemorate a bereavement. Sir Peter Lely's *Sir Thomas Thynne* is a stock type of portrait for which the artist was much in demand by society; his *Concert*, on the other hand, is an exceptional and personal early work: the musician playing the bass-violin is probably a self-portrait and the subject an allegory of Music in the service of Love and Beauty.

Pietro da Cortona
Cortona 1596 – 1669 Rome
Faith, Hope and Charity, c1640s
Canvas, 155 × 127.9 cm
Gambier-Parry bequest 1966, CIG 316

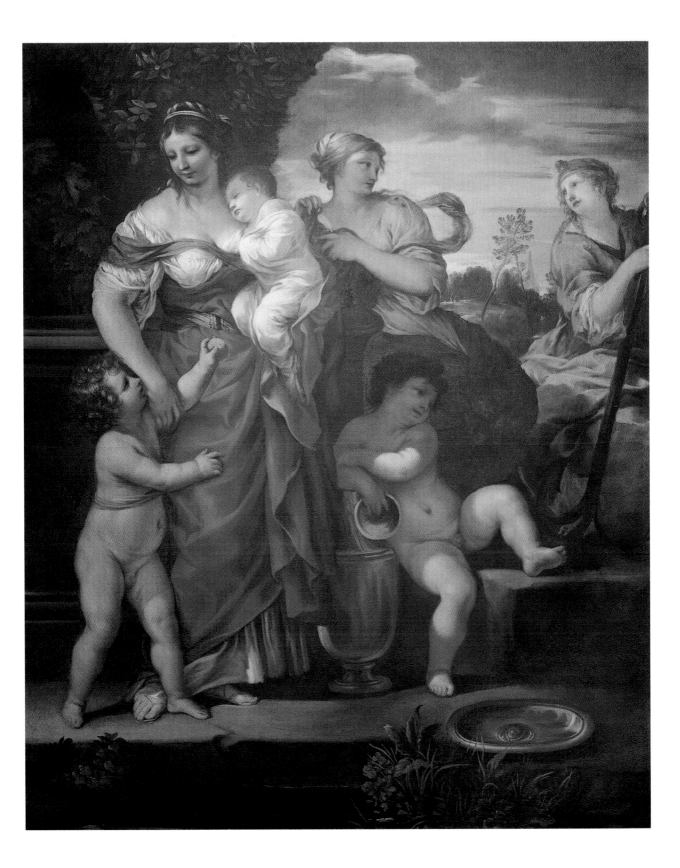

1

Domenico Fetti
Rome 1589 – 1623 Venice
Vertumnus and Pomona, 1621-23
Copper, 18.7 × 25.7 cm
Seilern bequest 1978, CIG 122

2

Domenico Fetti
Rome 1589 – 1623 Venice
Adam and Eve at work
Panel, 85.5 × 67 cm
Gift in memory of Tancred Borenius
1950, CIG 123

3

Giovanni Battista Salvi called
Sassoferrato
Sassoferrato 1609 – 1685 Rome
The Virgin in prayer
Canvas, 61.3 × 49.3 cm
Gambier-Parry bequest 1966, CIG 390

2

3

4
Gianfrancesco Barbieri called
Guercino
Cento 1591 – 1666 Bologna
Aurora, 1621
Red chalk on pale grey laid paper,
24.85 × 27.2 cm
Sir Robert Witt bequest 1952,
no.1328

5
Attributed to Girolamo Forabosco
Padua c1605 – 1697 Venice
Portrait of a man
Canvas, painted surface 108 × 90 cm
Lee bequest 1947, CIG 133

4

5

1
Sir Peter Paul Rubens
Siegen 1577 – 1640 Antwerp
The Descent from the Cross, 1611
Panel, 115.2 × 76.2 cm
Lee bequest 1947, CIG 359

2
Sir Peter Paul Rubens
Siegen 1577 – 1640 Antwerp
The Visitation, c1611-13
Panel, 83.2 × 30.3 cm
Seilern bequest 1978, CIG 361

3
Sir Peter Paul Rubens
Siegen 1577 – 1640 Antwerp
The Presentation in the Temple, c1611-13
Panel, 83 × 30.4 cm
Seilern bequest 1978, CIG 360

By fortunate chance these three *modelli* or preparatory oil-sketches for one of Rubens's major church commissions were recently united for the first time since Rubens's day. The central panel from Viscount Lee's collection is now joined by the *modelli* from Count Seilern's collection for the inside wings of the same altarpiece. The *modello* for the outside of the wings, now in the Alte Pinakothek, Munich, shows St Christopher, patron saint of the Arquebusiers' Guild which commissioned the altarpiece for its chapel in Antwerp Cathedral, where it is still displayed.

The subject was first negotiated in March 1611 and formally commissioned in September, the central panel completed in 1612 and the wings early in 1614. This oil-sketch of the *Deposition*, large, finely finished and carefully coloured, was probably the contract-winning *modello*, and the strikingly different *modelli* for the wings, here and at Munich, may well have been produced later.

The name of the legendary patron saint, Christopher, who is shown carrying the Christ Child across a river, signifies 'Christ-bearing', and this theme was made the subject of every scene: at the Visitation the Virgin bears the unborn Child at her meeting with Elizabeth; at the Presentation Simeon holds aloft the infant Christ as he recites his hymn of joy; at the Deposition the mourners are arranged in a striking manner, each participant reaching out to assist in the bearing of Christ's body, expressing at the same time the meaning of the Eucharist. The artist had recently returned from Italy and sources in Italian art are evident here, combined with native traditions; the image thus created of the Deposition is one of the most celebrated ever painted of the subject.

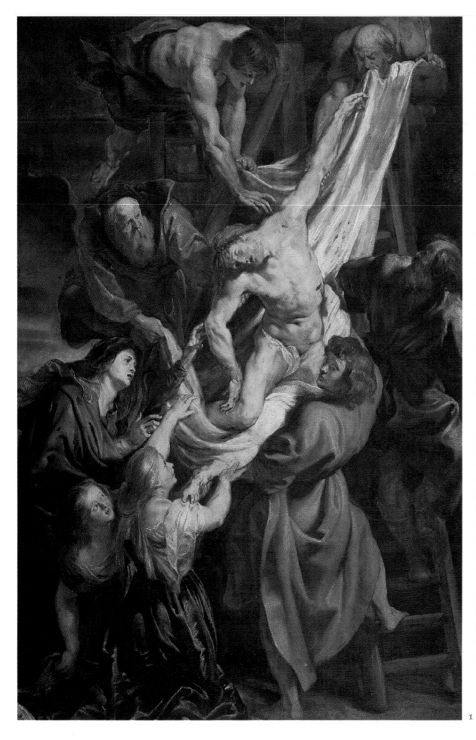

1

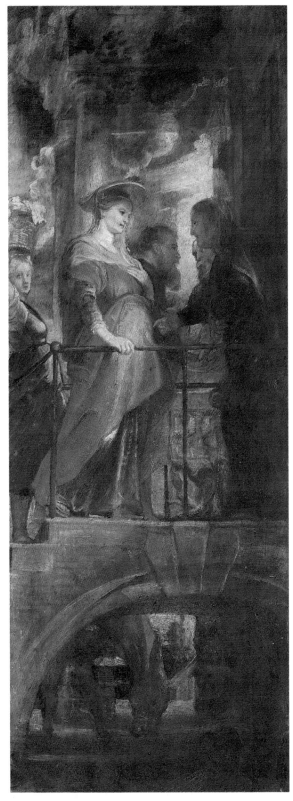

2

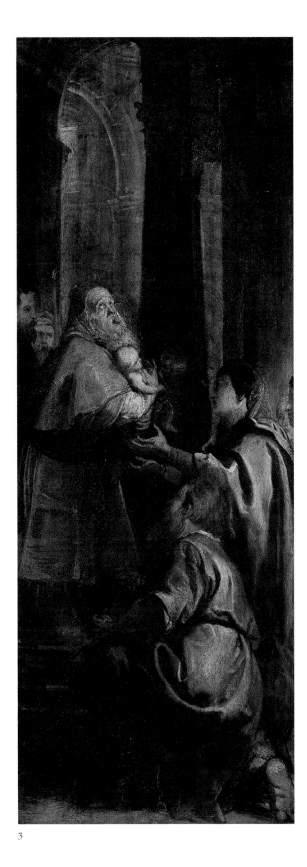

3

1

Sir Peter Paul Rubens
Siegen 1577 – 1640 Antwerp
The Bounty of James I triumphing over
Avarice, c1632-33
Panel, 46.2 × 30.8 cm
Seilern bequest 1978, CIG 377

2

Sir Peter Paul Rubens
Siegen 1577 – 1640 Antwerp
The death of Achilles, c1630-35
Panel, 107.1 × 109.2
Seilern bequest 1978, CIG 375

3

Sir Peter Paul Rubens
Siegen 1577 – 1640 Antwerp
Esther before Ahasuerus, 1620
Panel, 50.1 × 47.2 cm
Seilern bequest 1978, CIG 367

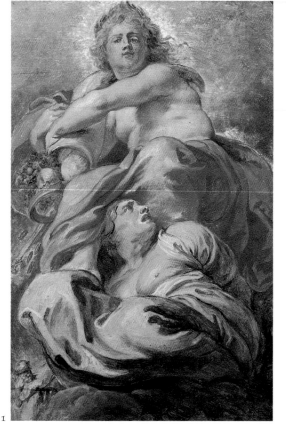

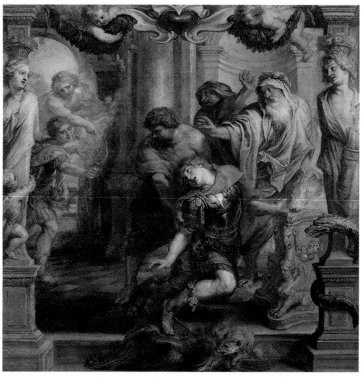

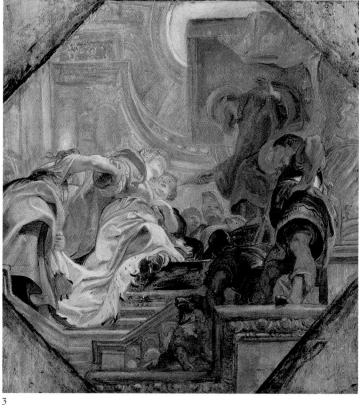

4

Sir Peter Paul Rubens
Siegen 1577 – 1640 Antwerp
The Family of Jan Breugel the Elder,
*c*1612-13
Panel, 125.1 × 95.2 cm
Seilern bequest 1978, CIG 362

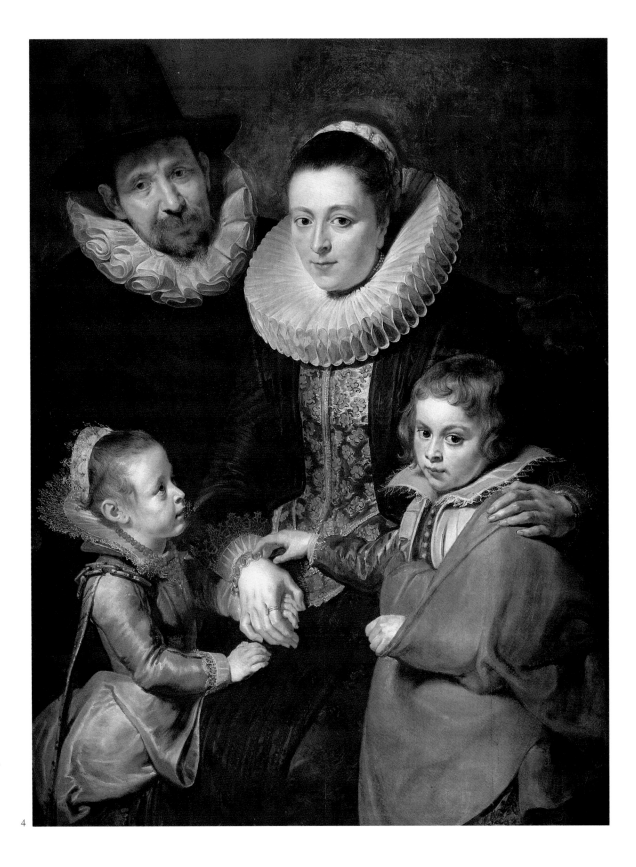

4
Sir Peter Paul Rubens
Siegen 1577 – 1640 Antwerp
The Family of Jan Breugel the Elder,
*c*1612-13
Panel, 125.1 × 95.2 cm
Seilern bequest 1978, CIG 362

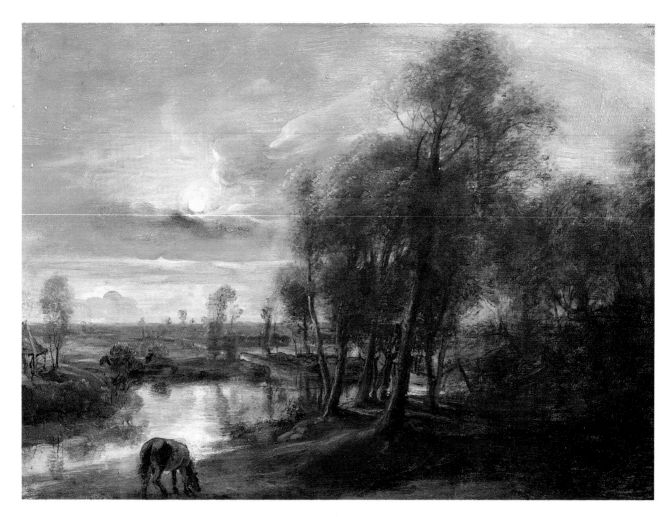

Sir Peter Paul Rubens
Siegen 1577 – 1640 Antwerp
Landscape by moonlight, c1635-40
Panel, 64 × 90 cm
Seilern bequest 1978, CIG 380

Many of Rubens's landscapes were
painted for his own pleasure during
the last years of his life, when he with-
drew as often as possible to his new
country estate of Het Steen. The
castle of Het Steen can be seen in
some of these views; in others, such as
this, the surrounding countryside
appears to be portrayed, bathed in the
light of different times of day, explor-
ing the effects of sunrise and sunset
or, as here, moonlight. Inspired orig-
inally perhaps by moonlit biblical
scenes, especially those of Adam
Elsheimer, the artist achieves here for
the first time a night view without

human figures. Recent scientific exam-
ination has revealed that this effect of
nocturnal solitude, unique among
Rubens's paintings, was achieved only
after experimenting with groups of
figures discovered to be hastily
sketched in beneath the paint's fin-
ished surface. In addition to the graz-
ing horse there was a group including
a woman and baby, conceivably the
Holy Family, beneath the central tree,
warmed by a blazing fire in the fore-
ground. Subsequently, Rubens added
panels to the top and right side and
peopled this extended landscape with
a number of figures which may be
nymphs and satyrs. Having painted
these out, the artist allowed the view
to be dominated by the moon and its
reflections, and by the stars, one
shooting, others glittering through

foliage. The first recorded owner of
the picture was Reynolds and its
influence on generations of English
artists, including Gainsborough and
Constable, adds lustre to its history.

Sir Peter Paul Rubens
Siegen 1577 – 1640 Antwerp

The Entombment, c1615-16

Panel, 83.1 × 65.1 cm

Seilern bequest 1978, CIG 365

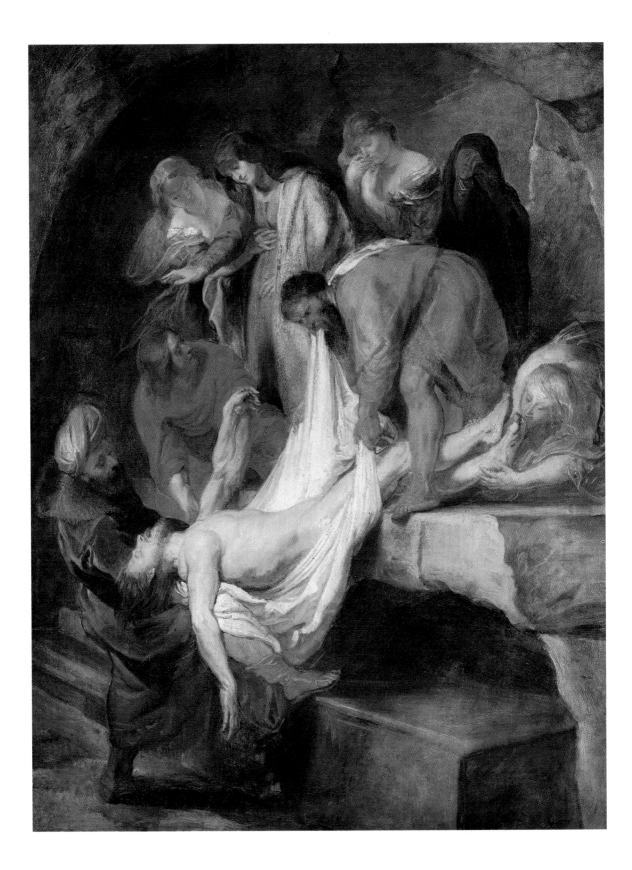

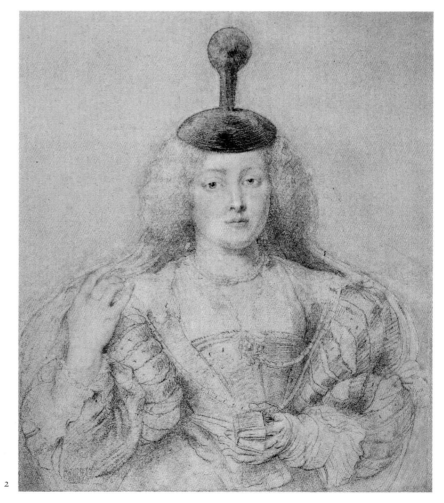

1

1
Sir Peter Paul Rubens
Siegen 1577 – 1640 Antwerp
Study for the *'Bath of Diana'*, c1635-40
Pen and iron gall ink on cream laid
paper, 29.1 × 50.9 cm
Seilern bequest 1978

2
Sir Peter Paul Rubens
Siegen 1577 – 1640 Antwerp
Helena Fourment, c1630
Black and red chalk heightened with
white, pen and iron gall ink, on white
laid paper, 61.2 × 55 cm
Seilern bequest 1978

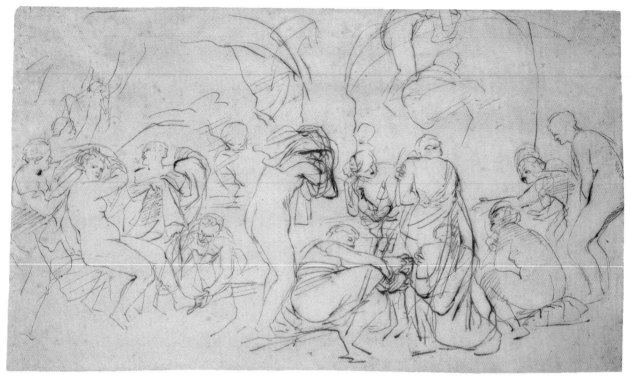

2

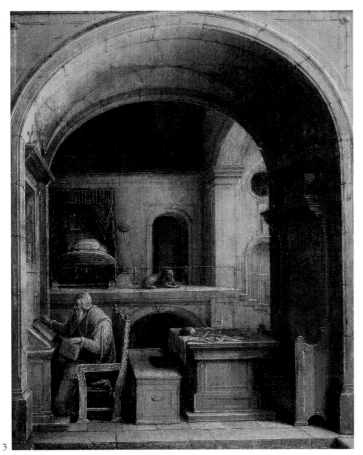

3

3
Hendrick van Steenwyck the
Younger
Frankfurt-am-Main 1580 –
1649 London
St Jerome in his study, 1624
Panel, 27 × 21.7 cm
Seilern bequest 1978, CIG 423

4
Frans Francken the Younger and
David Teniers the Younger
Antwerp 1581 – 1642 Antwerp;
Antwerp 1610 – 1690 Brussels
The picture gallery of Pieter Stevens (?),
*c*1640-48
Panel, 58.5 × 79 cm
Seilern bequest 1978, CIG 137

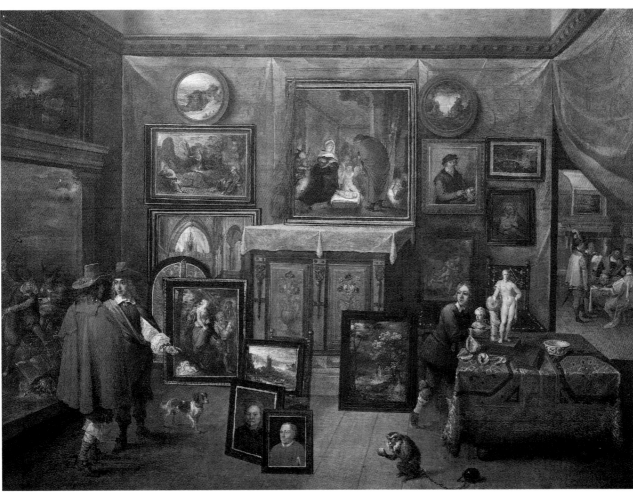

4

1

Sir Anthony Van Dyck
Antwerp 1599 – 1641 London
Man bending forward, c1617
Black chalk, white chalk with
heightenings, on pale buff laid paper,
27 × 43.15 cm (maximum extensions)
Sir Robert Witt bequest 1952,
no.1664

2

David Teniers the Younger
Antwerp 1610 – 1690 Brussels
Rocky landscape, 1634?
Graphite on white laid paper,
18 × 29.4 cm
Sir Robert Witt bequest 1952,
no.3211

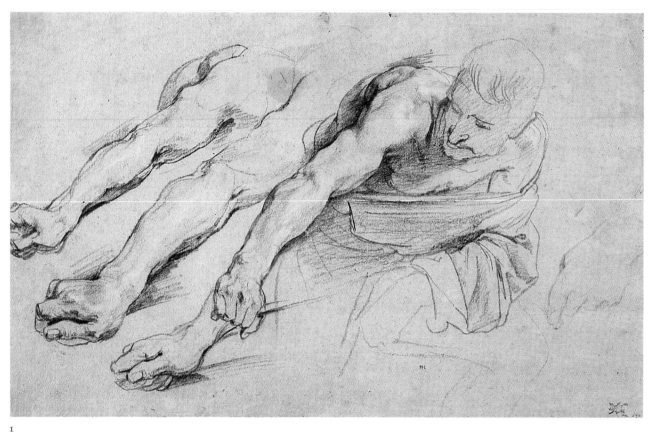

1

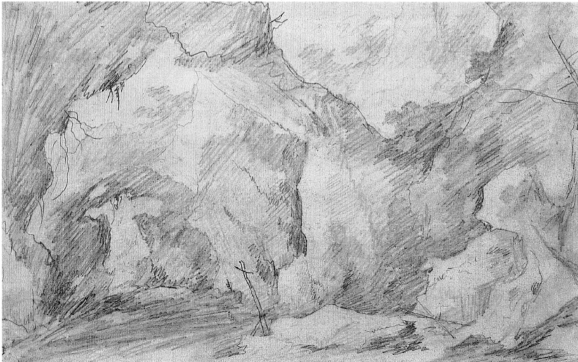

2

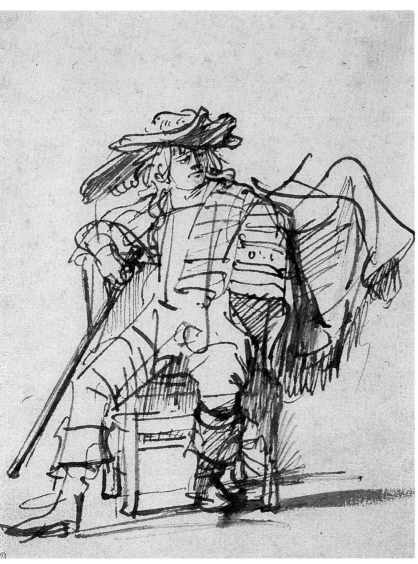

3

Rembrandt van Rijn
Leyden 1606 – 1669 Amsterdam
A seated actor, c1635
Pen and iron gall ink on pale buff laid
paper, 18.5 × 14.4 cm
Seilern bequest 1978

4

Rembrandt van Rijn
Leyden 1606 – 1669 Amsterdam
View of Diemen
Pen and iron gall ink and wash on laid
paper, 8.8 × 15.5 cm
Seilern bequest 1978

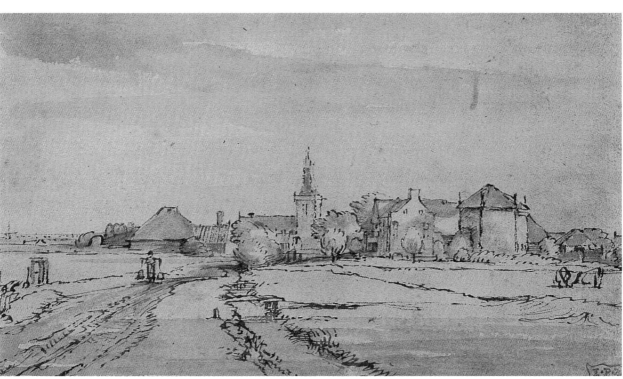

4

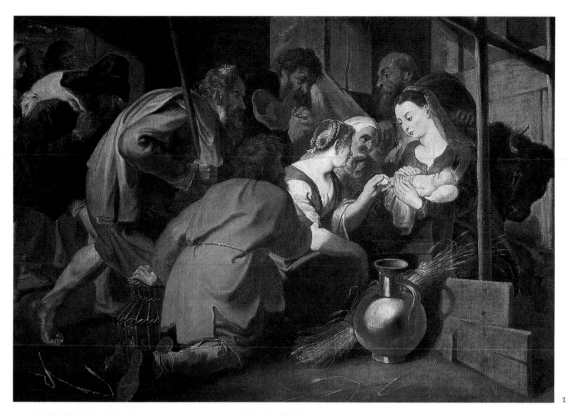

1
Sir Anthony Van Dyck
Antwerp 1599 – 1641 London
The Adoration of the Shepherds,
c1616-18
Canvas, 115.3 × 163.7 cm
Seilern bequest 1978, CIG 102

2
Sir Anthony Van Dyck
Antwerp 1599 – 1641 London
Portrait of a man in an armchair,
c1616-18
Panel, 120.9 × 80.8 cm
Seilern bequest 1978, CIG 103

3
Jacques Blanchard
Paris 1600 – 1638 Paris
Charity, 1637
Canvas, 10.8 × 83.8 cm
Lee bequest 1947, CIG 31

4
Claude Gellée called Claude
Lorrain
Chamagne 1600 – 1682 Rome
Landscape with an imaginary view of
Tivoli, 1642
Copper, 21.6 × 25.7 cm
Seilern bequest 1978, CIG 64

3

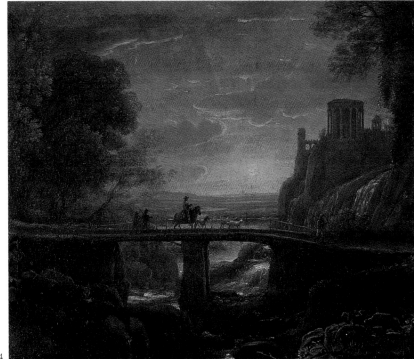

4

1

Sir Peter Lely
Soest 1618 – 1680 London
The concert ('Lely and his family'), late
1640s
Canvas, 123.1 × 234 cm
Lee bequest 1947, CIG 216

2

William Dobson
London 1611 – 1646 London
An old and a younger man, early 1640s
Canvas, 110.2 × 118.6 cm
Lee bequest 1947, CIG 97

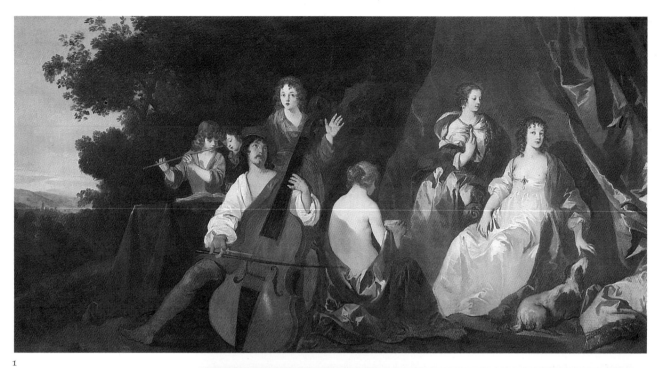

1

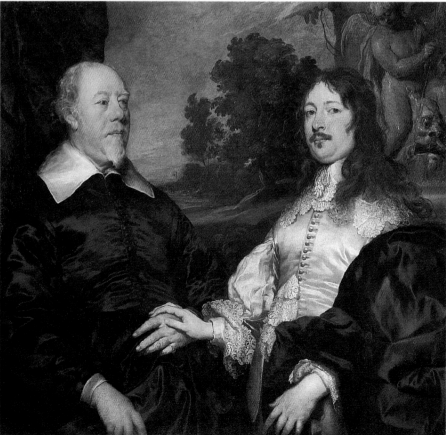

2

Sir Peter Lely
Soest 1618 – 1680 London
Sir Thomas Thynne, later 1st Viscount
Weymouth
Canvas, 125 × 102.2 cm
Lee bequest 1947, CIG 217

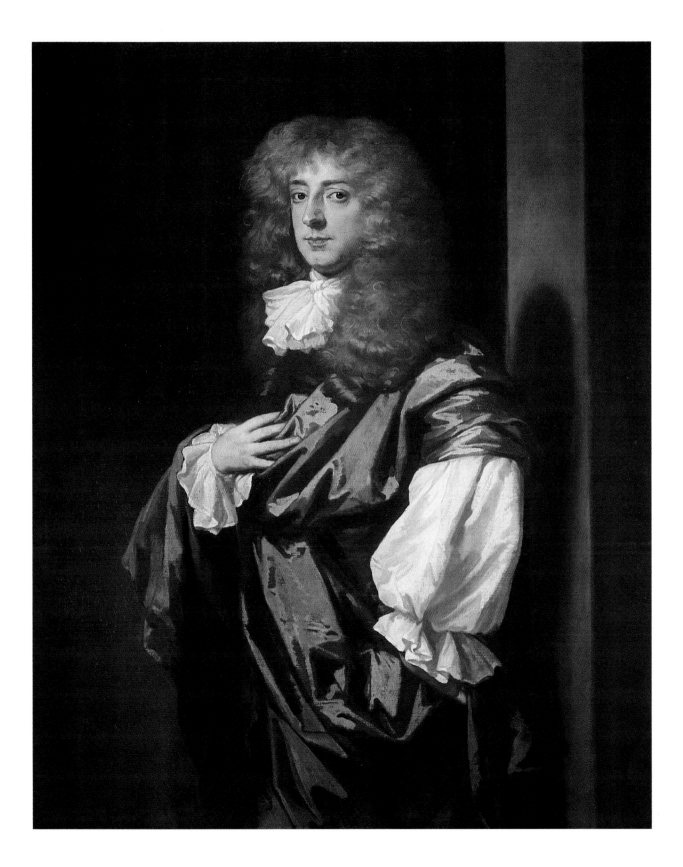

Late Baroque and Rococo

The particular riches of the Courtauld collections' eighteenth-century paintings are chiefly in Italian, more especially Venetian, and in English art, and this is largely due to the tastes of two benefactors, Count Seilern and Lord Lee. As for drawings, the extensive Witt holdings are augmented by important items from the Spooner collection; together they provide an outstanding group of English drawings and watercolours, while Count Seilern's bequest adds some notable Italian and also French drawings. Standing somewhat apart from the rest is a rare work, unique of its kind in this country, Goya's full-length portrait from the Lee collection of *Don Francisco de Saavedra*, which dates from the very end of the century.

While Rubens dominates the seventeenth-century collection, Giambattista Tiepolo, the greatest decorative painter of the age, holds a similar but more modest position among the eighteenth-century holdings, and this again is due to Count Seilern's zeal in gathering his works together: a dozen small paintings, chiefly *modelli*, and nearly 40 drawings, including a number by Giambattista's son Giandomenico. The paintings span the whole of Giambattista's career, from the preparatory oil-sketch for the very earliest of his many ceiling frescoes, in the Palazzo Sandi in Venice, to the complete set of five surviving *modelli* for his last great commission for the Spanish monarchy, the seven altarpieces executed for the monastery church of San Paschal Baylon at Aranjuez; three of these are reproduced here. Among Tiepolo's corpus of surviving drawings is a brilliantly inventive series on the theme of the *Holy Family*, of which three were in Count Seilern's collection, and one, illustrated here, in the Samuel Courtauld collection.

Outstanding among the other Venetian works, which include a painting and over a dozen drawings by Francesco Guardi, are those by Canaletto, notably two finished pen-and-wash views, one Venetian, of Piazza San Giacomo di Rialto and the other, most fittingly, *A View from Somerset Gardens looking towards London Bridge*. From Bologna comes the expressive little *Virgin with the Instruments of the Passion* by Giuseppe Maria Crespi ('lo Spagnoletto'), the most original and greatest painter of this last period of the school which originated in the Carracci.

French eighteenth-century art is represented almost exclusively by the drawings collections, although there is an *Italian landscape* painted by Jean Barbault which exemplifies the continuing attraction of Italy felt by French artists. Fragonard, whose unusually reflective portrait drawing, '*La Résignée*', is illustrated here, was among those drawn to Italy, while Watteau, of whom there are nine drawings in the Seilern collection, was perhaps the greatest exponent of 'Rubenisme': his outstanding *Faun* is a worthy companion to the works by Rubens in the same collection.

Rubens, too, was a significant influence on Gainsborough: the Witt collection contains many of his landscape drawings, including *Wooded landscape*, while among his paintings in the collections is the *Artist's wife*, one of the finest portraits in the Courtauld Galleries, exceptional for its touching intimacy. In contrast to Gainsborough's sophistication, Arthur Devis's *Family group* is a delightful instance of a more naive art. Devis was the first English painter to devote himself to the conversation piece in which he had a successful London practice throughout the mid-century. Tilly Kettle's achievement was to be the first British artist of note to visit India and to work there as a portrait painter; a full-length double portrait in the Lee collection of the Sealy brothers was painted in Calcutta in 1773, but before that his practice had attracted the patronage of, among others, Oxford undergraduates and academics, of which *Dr Daniel Lysons* is a fine example. Other British portraits from Lord Lee's collection reproduced here are Romney's *Georgiana*, *Lady Greville* and Raeburn's *Mrs Malcolm*.

Principally from the Spooner gift and bequest come drawings and watercolours which show landscape in eighteenth-century British art at its grandest: works by Alexander and John Robert Cozens, Towne and Sandby, as well as by Gainsborough, are illustrated here.

Giovanni Battista Tiepolo
Venice 1696 – 1770 Madrid
Allegory of the power of Eloquence, c1725
Canvas, 49.2 × 70.8 cm
Seilern bequest 1978, CIG 445

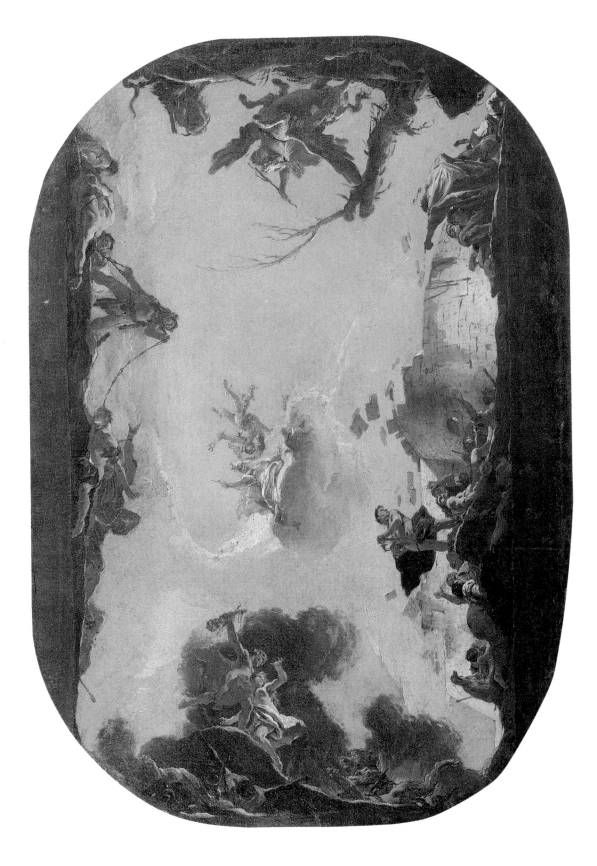

1
Giovanni Battista Tiepolo
Venice 1696 – 1770 Madrid
The Immaculate Conception, 1767
Canvas, 63.7 × 38.9 cm
Seilern bequest 1978, CIG 451

2
Giovanni Battista Tiepolo
Venice 1696 – 1770 Madrid
The Stigmatisation of St Francis, 1767
Canvas, 63.5 × 38.9 cm
Seilern bequest 1978, CIG 455

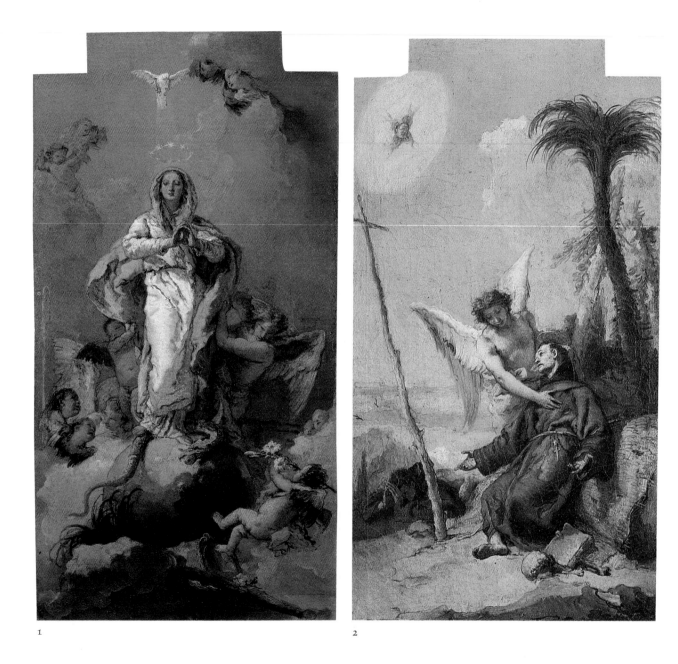

1

2

3
Giovanni Battista Tiepolo
Venice 1696 – 1770 Madrid
St Paschal Baylon's vision of the Eucharist,
1767
Canvas, 63.7 × 38.9 cm
Seilern bequest 1978, CIG 454

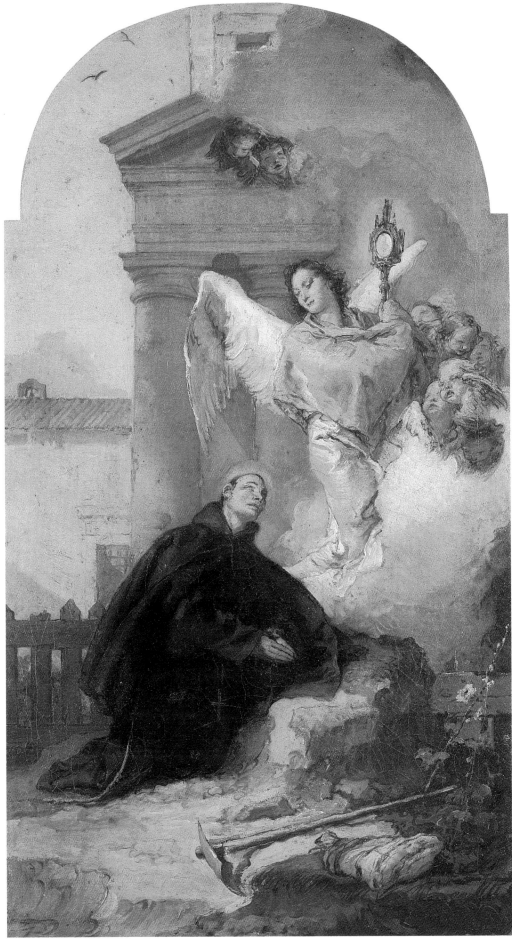

3

1
Giovanni Battista Tiepolo
Venice 1696 – 1770 Madrid
Apollo as protector of the arts
Pen and ink and wash over traces of
black chalk, 26.3 × 20.8 cm
Seilern bequest 1978

2
Giovanni Battista Tiepolo
Venice 1696 – 1770 Madrid
The Holy Family with St Joseph reading
Pen and ink and wash, 28.5 × 21.5 cm
Seilern bequest 1978

3
Giovanni Battista Tiepolo
Venice 1696 – 1770 Madrid
The martyrdom of St Agatha, c1734
Canvas, 48.9 × 30 cm
Seilern bequest 1978, CIG 449

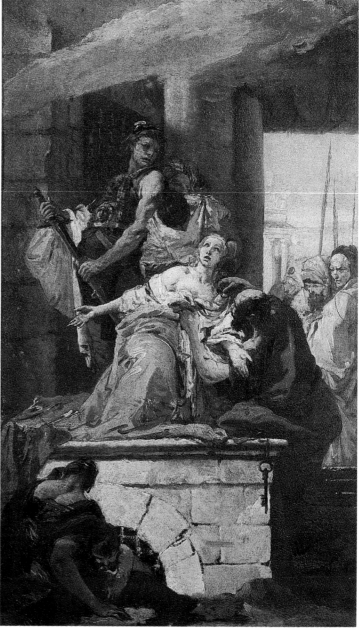

3

1

2

4
Giovanni Battista Tiepolo
Venice 1696 – 1770 Madrid
St Aloysius Gonzaga in glory, c1726
Canvas, 58.1 × 44.6 cm
Seilern bequest 1978, CIG 447

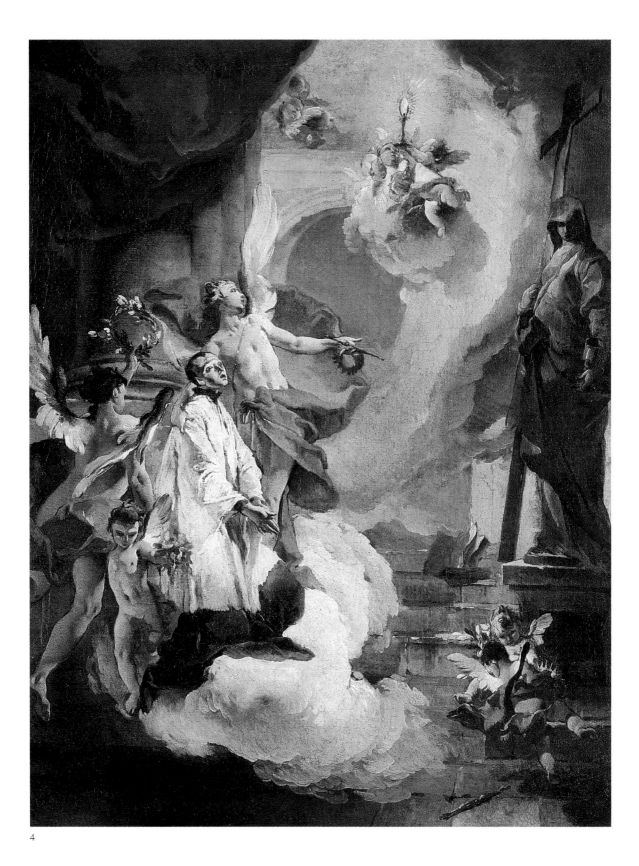

4
Giovanni Battista Tiepolo
Venice 1696 – 1770 Madrid
St Aloysius Gonzaga in glory, c1726

Sebastiano Ricci
Belluno 1659 – 1734 Venice
The Adoration of the Magi, c1726
Canvas on panel, 50.8 × 48.1 cm
Seilern bequest 1978, CIG 342

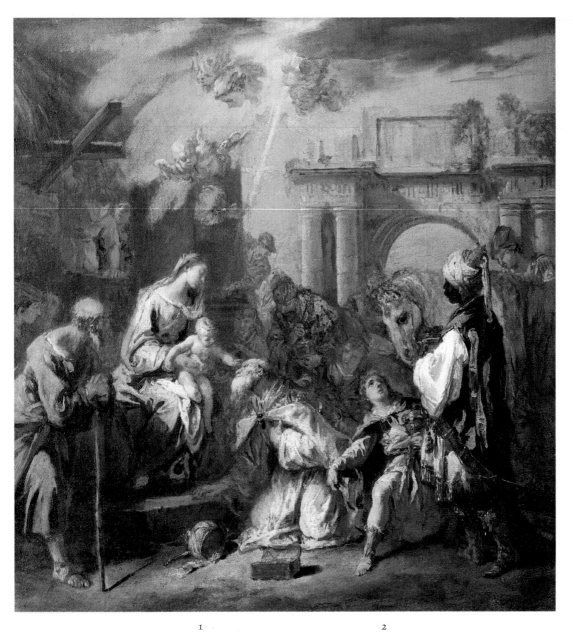

1
Antonio Canaletto
Venice 1697 – 1768 Venice
Piazza di San Giacomo di Rialto, Venice,
c1760
Graphite, pen and brown ink, with
carbon black ink washes, on white laid
paper, 31.85 × 43.3 cm (maximum
extensions)
Seilern bequest 1978

2
Antonio Canaletto
Venice 1697 – 1768 Venice
View from Somerset House Gardens,
looking towards London Bridge, c1750
Graphite, pen and iron gall ink, carbon
black ink washes, on pale buff laid
paper, 23.5 × 73.2 cm (maximum
extensions)
Seilern bequest 1978

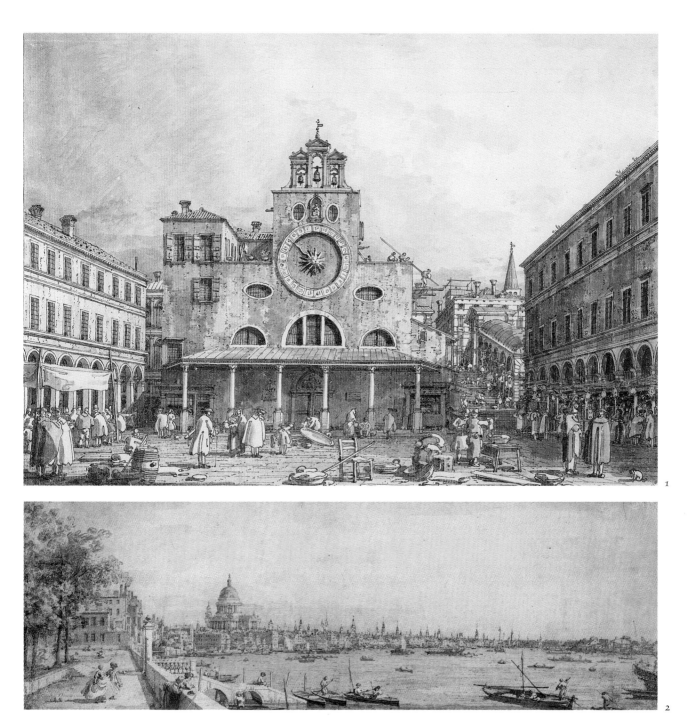

1

2

1

Antonio Canaletto
Venice 1697 – 1768 Venice
A standing man, seen from the front
Pen and wash over black chalk,
30 × 17.5 cm
Sir Robert Witt bequest 1952, no.346

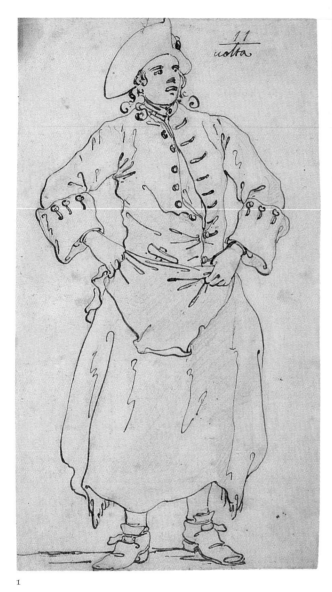

1

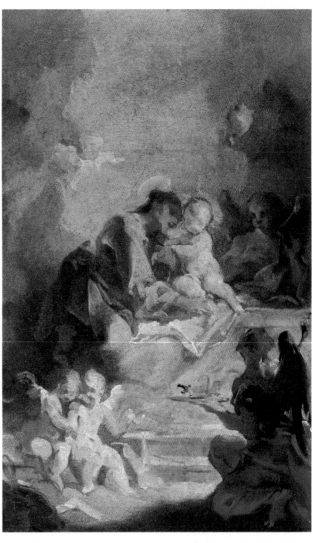

2

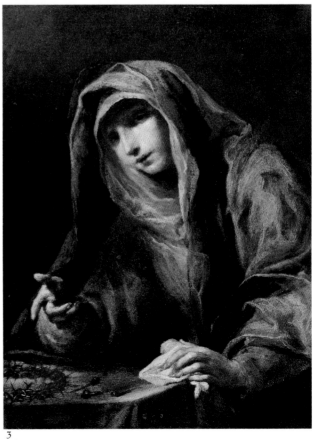

3

2
Giovanni Battista Pittoni
Venice 1687 – 1767 Venice
St Anthony of Padua adoring the Christ Child
Paper on canvas, 23 × 14.3 cm
Johannes Wilde bequest 1970, CIG 325

3
Giuseppe Maria Crespi
Bologna 1665 – 1747 Bologna
The Virgin with the Instruments of the Passion, c1730
Copper, 22.3 × 16.9 cm
Seilern bequest 1978, CIG 79

4
Francesco Solimena
Canale di Serino (Avallino) 1657 – 1747 Barra (Naples)
The Assumption of the Virgin, before 1725
Canvas, 127.3 × 101.3 cm
Gambier-Parry bequest 1966, CIG 415

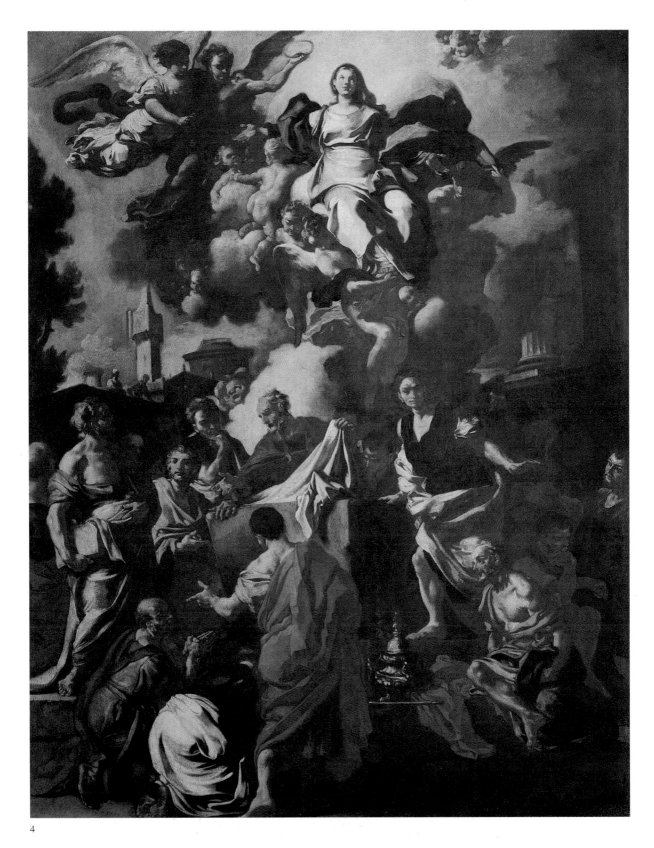

4

1
Jean-Antoine Watteau
Valenciennes 1648 – 1721 Nogent-sur-Marne
A faun, c1712-15
Black, red and white chalk on buff laid paper, 28.5 × 21.1 cm
Seilern bequest

2
Jean-Honoré Fragonard
Grasse 1732 – 1806 Paris
'La Résignée', 1765
Red chalk on off-white laid paper, 22.5 × 17.2 cm
Seilern bequest 1978

3
Jean Barbault
Near Beauvais c1705 – 1766 Rome
Italian landscape, 1749
Canvas, 74.6 × 98.9 cm
Seilern bequest 1978, CIG 19

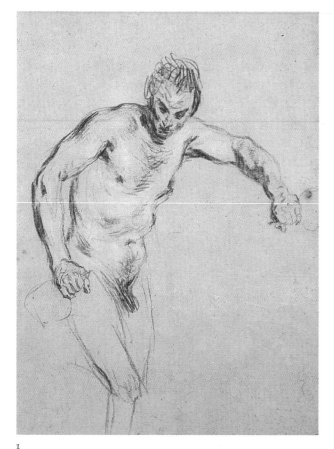

1

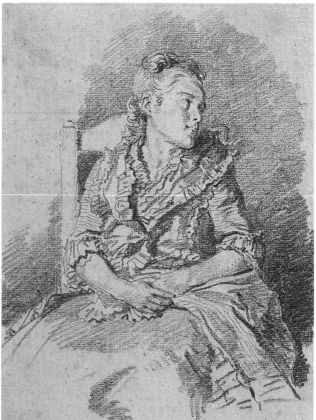

2

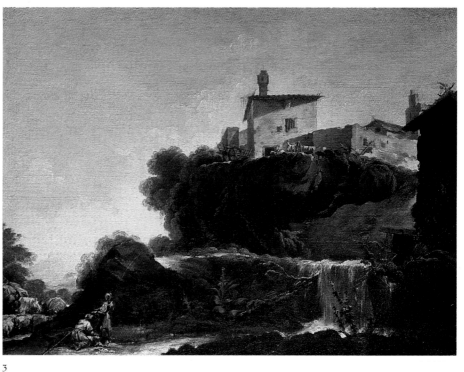

3

Arthur Devis
Preston 1712 – 1787 London
Family group, late 1740s
Canvas, painted surface
88.7 × 119.7 cm
Lee bequest 1947, CIG 93

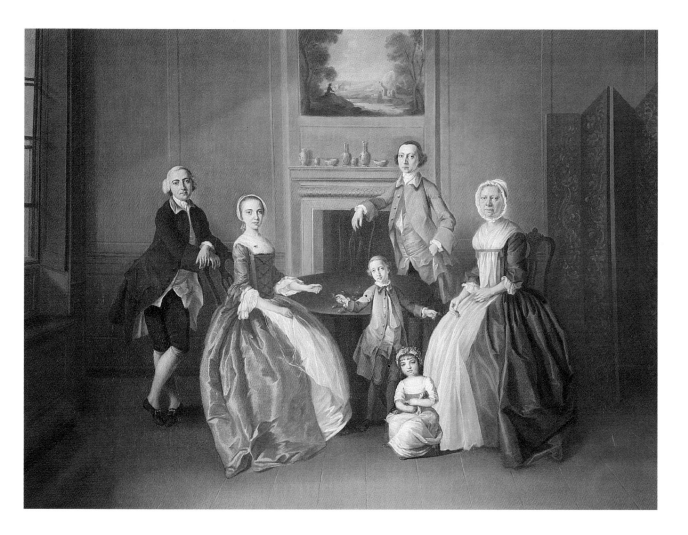

1
George Romney
Dalton-in-Furness 1734 –
1802 Kendal
Georgiana, Lady Greville, c1771-72
Canvas, 76.2 × 63.5 cm
Lee bequest 1947, CIG 344

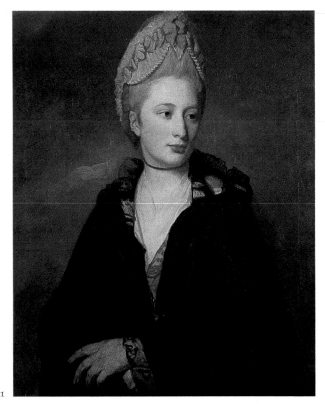

1

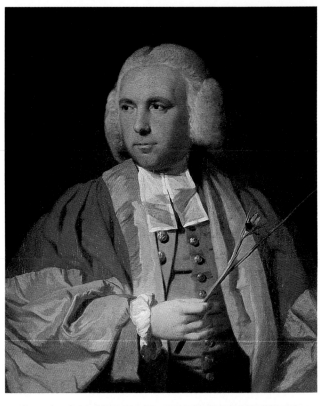

2

2
Tilly Kettle
Exeter 1735 – 1786 Aleppo
Dr Daniel Lysons, c1762-68
Canvas, 76.5 × 64.3 cm
Lee bequest 1947, CIG 204

3
Sir Henry Raeburn
Stockbridge 1756 – 1823 Edinburgh
Margaret Pasley, Mrs George Malcolm
(1742-1811)
Canvas, 75.9 × 63.6 cm
Lee bequest 1947, CIG 334

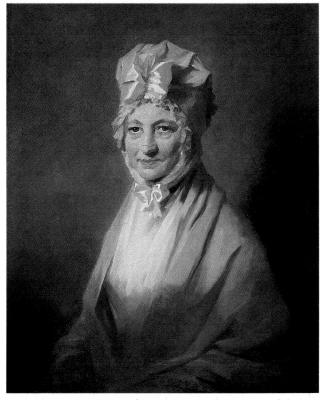

3

4
Thomas Gainsborough
Sudbury 1727 – 1788 London
Margaret Burr, Mrs Gainsborough,
c1779
Canvas, 76.6 × 63.8 cm
Courtauld gift 1932, CIG 157

Gainsborough married Margaret Burr (1728-98) in 1746. Tradition in his wife's family held that for many years he painted Margaret on their wedding anniversary, although few portraits of her survive. That now in East Berlin shows her at the age of thirty: since she is here about fifty, a date of c1779 is assigned to the portrait. Contrasted with the sitter's frontally set head and direct, steady gaze is the movement created by the mantle, which she appears to be drawing back. Together with the hands, this forms a loose oval. This sophisticated spatial development of the device of feigned oval which usually surrounds bust-length portraits of the period may have begun in about 1773 with a portrait, now cut down, of Elizabeth Tyler, in a private collection. The liveliness of Mrs Gainsborough's pose in this sympathetic portait is complemented by the artist's rapid and sensuous handling of paint.

4

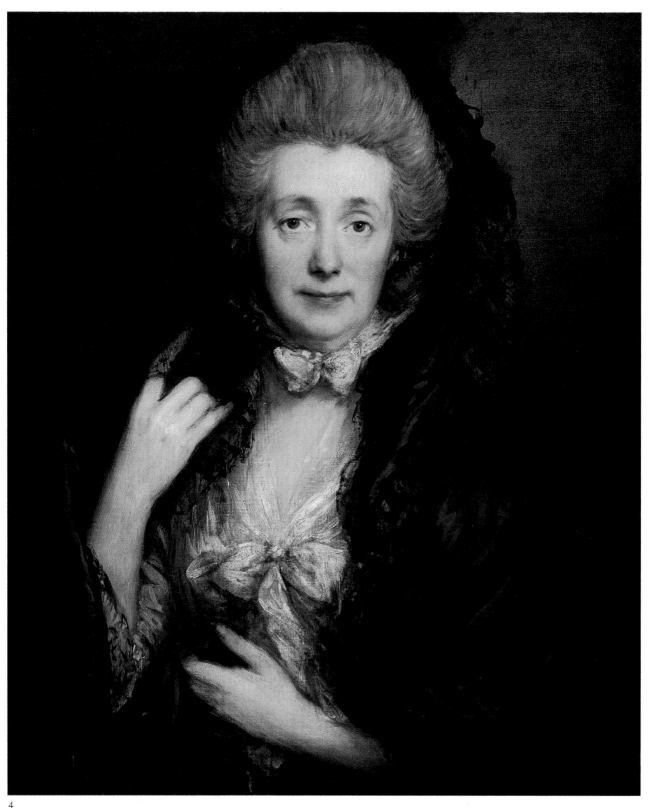

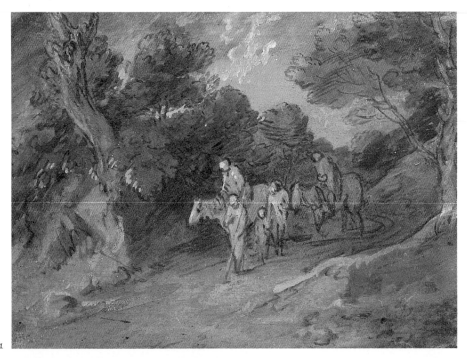

1

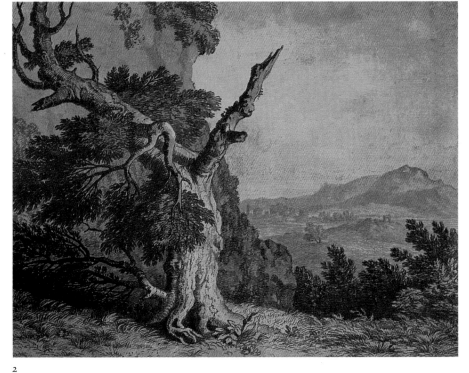

2

1
Thomas Gainsborough
Sudbury 1727 – 1788 London
A road through a wood, with figures on
horseback and on foot, mid-1780s
Black chalk, brown and grey ink,
heightening with white oil paint;
varnished; on pale buff laid paper,
22.1 × 30.5 cm
Sir Robert Witt bequest 1952,
no.1681

2
Alexander Cozens
St Petersburg 1717 – 1786 London
A blasted tree in a landscape, c1780
Graphite, brown ink washes, some
varnish, on laid paper, 32.2 × 41.3 cm
Spooner collection, S29

3
John Robert Cozens
London 1752 – 1797 London
The Castel Sant'Angelo, Rome, 1780
Graphite, black ink and blue
watercolour on white laid paper,
36 × 52.6 cm, on mount 41.5 × 58 cm
Spooner collection, S31

4
Paul Sandby
Nottingham 1725 – 1809 London
The Henry VIII gateway, Windsor, 1767
Graphite, watercolour and bodycolour
on white wove paper, 37 × 47.1 cm
Spooner collection, S84

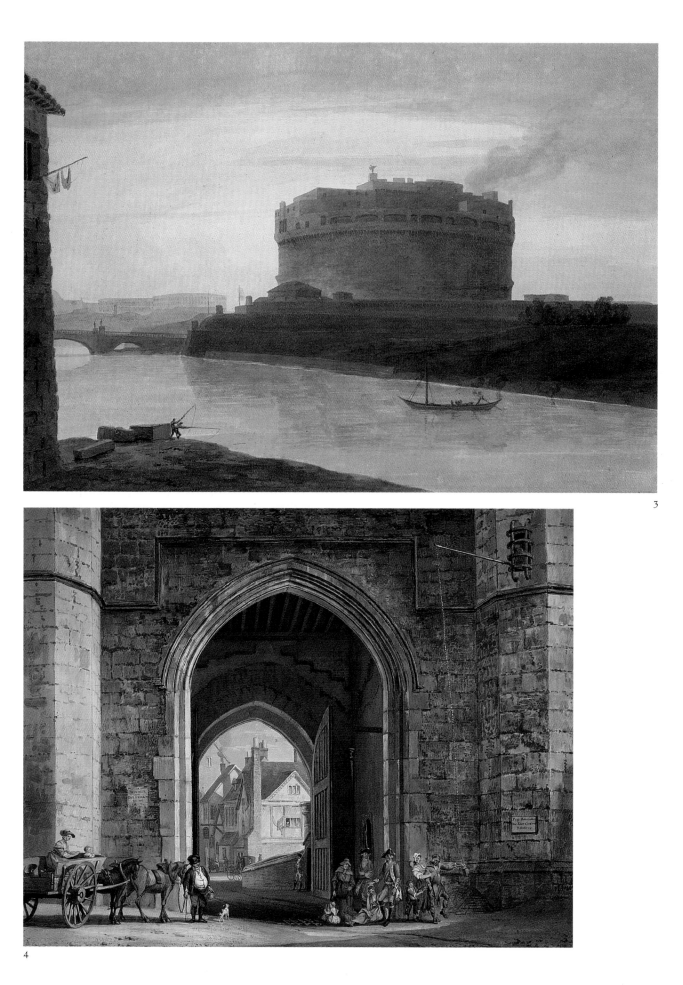

3

4

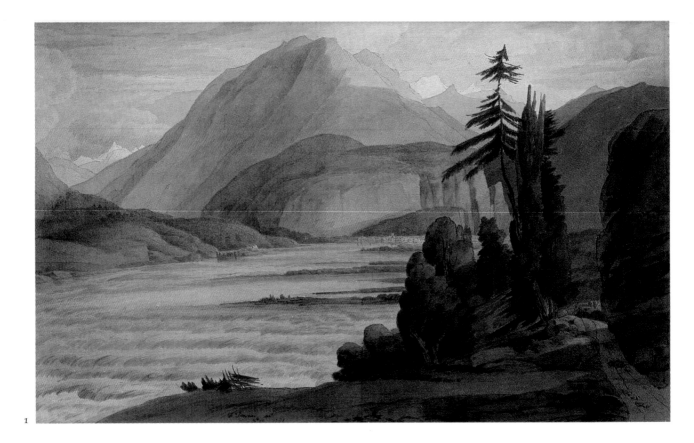

1

1
Francis Towne
Exeter? *c*1740 – 1816 **London**
In the valley of the Grisons, 1781
Graphite, brown-grey ink, yellow,
green, brown and blue watercolour
washes, on white laid paper,
38.8 × 57.2 cm
Spooner collection, s89

2
Thomas Girtin
London 1775 – 1802 **London**
Peterborough Cathedral from the west
*front, c*1794
Graphite and watercolour on white
wove paper, 40.7 × 27.1 cm
Spooner collection, s48

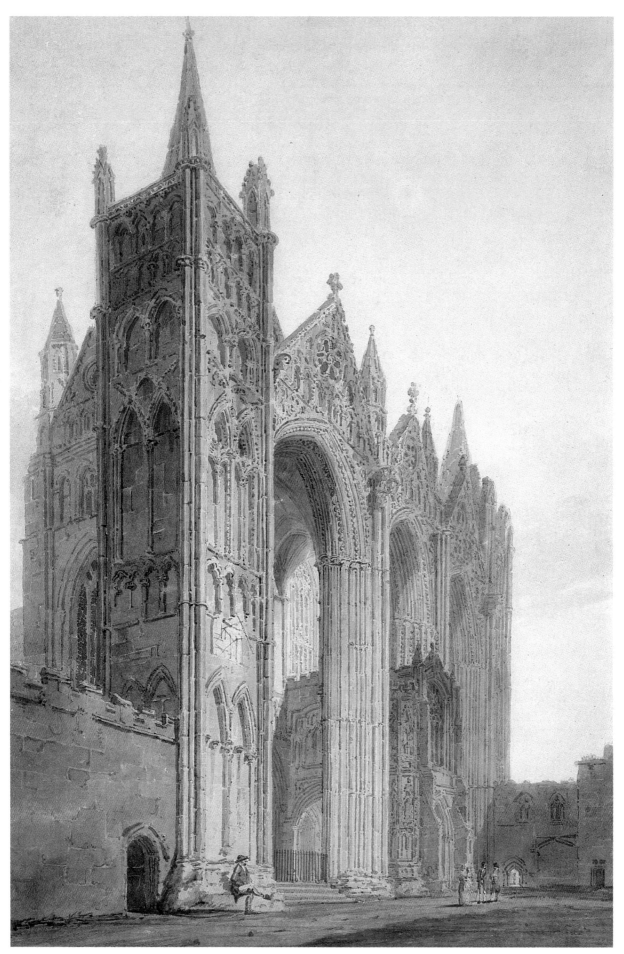

2

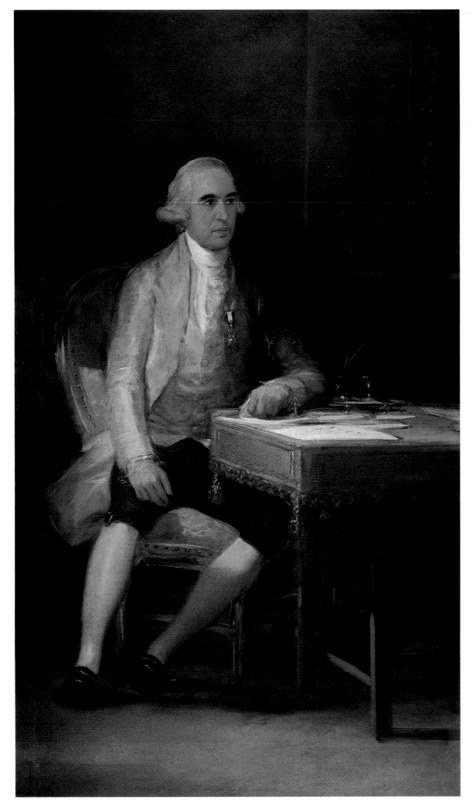

Francisco de Goya
Fuendetodos 1746 – 1828 Bordeaux
Don Francisco de Saavedra, 1798
Canvas, 200.2 × 119.6 cm
Lee bequest 1947, CIG 180

The Nineteenth Century

The nucleus of the nineteenth-century collections is, of course, Samuel Courtauld's foundation gift and bequest of 45 Impressionist and Post-Impressionist paintings, plus a handsome selection of mainly French nineteenth- and twentieth-century drawings, prints and watercolours, as well as a few Old Master paintings, and some contemporary British artists' work which he purchased whilst he was a founder-trustee of the London Artists' Association from 1925 to 1934. Many of the pictures are world famous, although it is not always realized by the general public that they belong to an institute of London University. The most splendid jewel in the crown is Manet's *A bar at the Folies-Bergère*, 1881-82, but the range of eight Cézannes and five Seurats show Courtauld responding to Roger Fry's advocacy of the merits of these two great masters (Courtauld bequeathed two more Cézannes and another six Seurats to members of his family). Three paintings by Gauguin, two of them Tahitian works of 1897, three Monets, two each by Boudin, Van Gogh, Toulouse-Lautrec and Camille Pissarro, as well as Renoir's ravishing *La Loge* (1874), give an idea of the wealth of the collection, which although numerically quite small is nevertheless of the highest quality.

Courtauld came late to collecting: he was forty-six when he began in 1922, but in the nine years up to the death of his wife in 1931 he collected with astonishing vigour and discernment, and continued to add to the collection even up to the year he died, when he bought Sisley's *Boats on the Seine* in 1947. Although collecting was for him a far from coldly intellectual pursuit, he had a shrewd sense of the historical importance of a work of art as well as responding to its aesthetic appeal. Thus, Renoir's *La Loge* attracted him both for its beauty and for its subject-matter, as well as for its importance as one of the paintings which had been included in the first Impressionist exhibition of April 1874. He responded to feminine beauty, and Gauguin's marble bust of his wife, *Mette-Sophie Gad* (1877), which he acquired in 1925, is a rare example of the artist's work in this medium. He was guided by the sculptor Paul Bouillot, who carved it with Gauguin's collaboration. Courtauld was also no doubt intrigued by Manet's *Déjeuner sur l'Herbe*, which we now know was a copy of the large version now in the Musée d'Orsay, Paris, that he made for a family friend, Commandant Lejosne, presumably in 1863 or even a year or so later.

Count Seilern's collection also contains important nineteenth-century pictures, including a noble late Cézanne, *'Route tournante'* of 1902-06, as well as Impressionist works by Degas, Pissarro, and Renoir. The Barbizon School is represented by a Daubigny and a Diaz, landscapes which Seilern inherited from his grandmother, Anna Woerishoffer.

The collections are rich in nineteenth-century drawings and watercolours, notably those forming part of Sir Robert Witt's collection, and thirteen superb Turner watercolours from Sir Stephen Courtauld's collection, which were given in his memory by his family, and from which three representative examples are here reproduced, culminating in the melancholy *Dawn after the Wreck* (c1841). Sir Robert's collection contains over 40 John Constable drawings, including three of East Bergholt church which are less finished than the Spooner collection drawing reproduced here, and one of Willy Lott's house. David Cox is also well represented, as is J F Lewis, whose *Street scene in Cairo — the street and mosque of Ghoreyah* is an excellent example of this artist's Middle Eastern speciality. Other leading artists whose work Witt collected assiduously were John Ruskin, James Ward and Sir David Wilkie; but he does not appear to have been much interested in the Pre-Raphaelites. This may well have been because collectors like J R Holliday of Birmingham had already made off with many of the best drawings by members of the Brotherhood. The Spooner collection, although strongest in the classic English eighteenth-century watercolourists, also has outstanding examples by Cotman, Cox, Samuel Palmer, John Varley and Peter De Wint.

The magnificent gouache, *Still life with apples, bottle and chair-back*, 1900-06, from the Samuel Courtauld collection is one of four Cézanne drawings he owned; to it are now added three from the Seilern collection, two from the 1880s, the third of the 1890s. There is one Van Gogh reed-pen and ink drawing of a *Tile factory*, vibrant with energy and subtle delineation. Sir Robert Witt's son, Sir John Witt, bequeathed to us, among other earlier works, some nineteenth-century drawings, including 21 by William Henry ('Bird's Nest') Hunt, about whom he published a monograph shortly before his death in 1982.

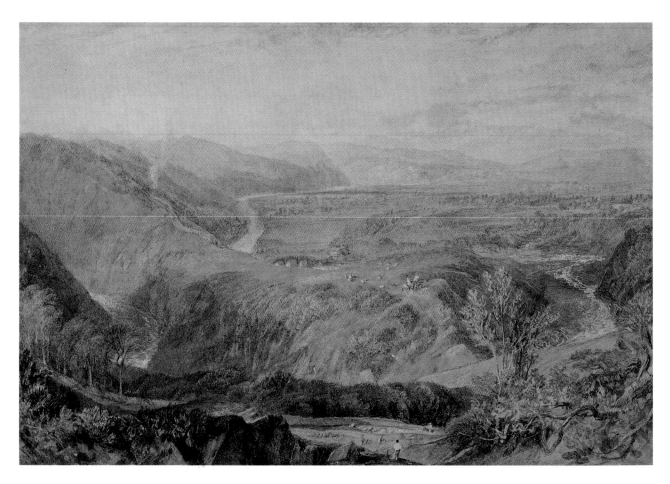

Joseph Mallord William Turner
London 1775 – 1851 London
The Crook of Lune, looking towards
Hornby Castle, c1816-18
Pencil, watercolour, white and other
coloured bodycolour, some black
chalk, on white wove paper,
29.1 × 42.9 cm
Sir Stephen Courtauld bequest 1974

1
John Constable
East Bergholt 1776 – 1837 London
East Bergholt church, c1817
Hard and soft pencil on off-white
wove paper, 31.7 × 23.8 cm
Spooner collection, s16

2
William Henry Hunt
London 1790 – 1864 London
Chaffinch nest and May blossom, c1845
Watercolour and white bodycolour on
white wove paper, 24.2 × 37.4 cm
Sir John Witt bequest 1982

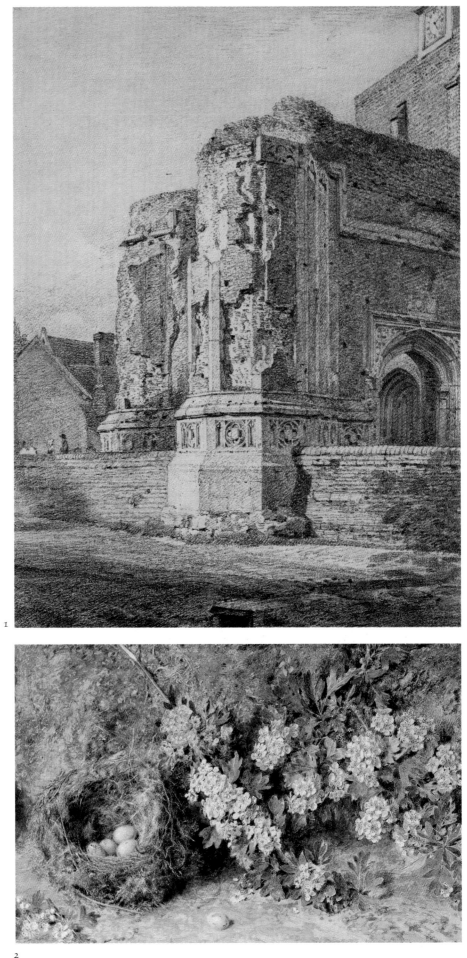

1

2

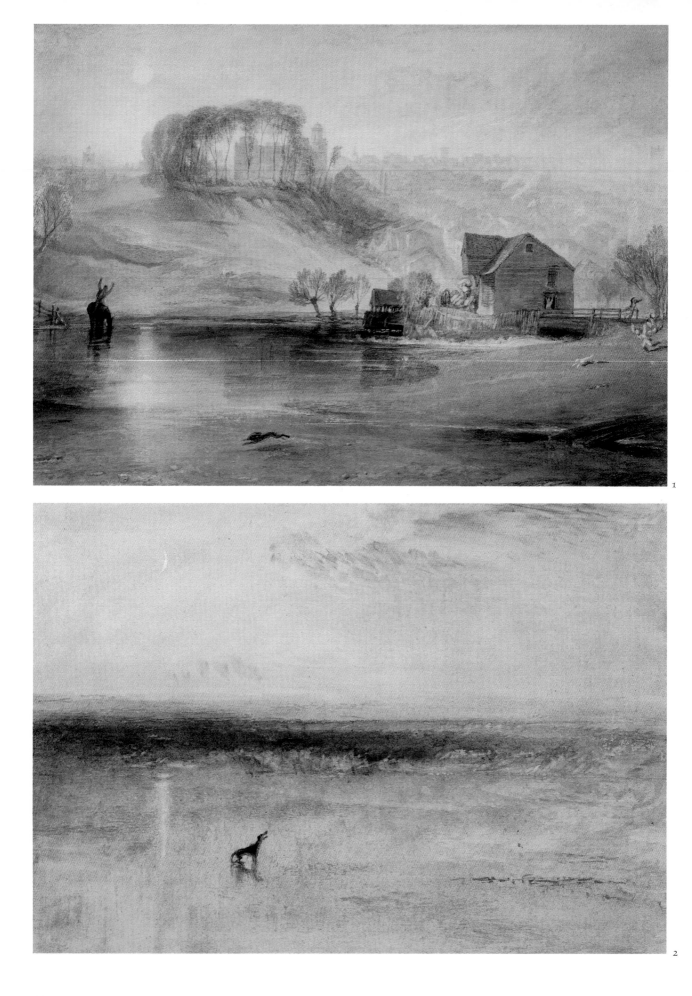

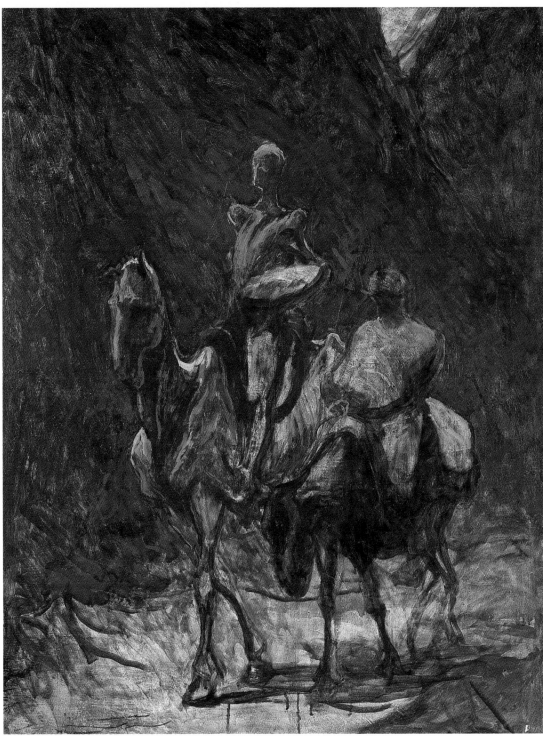

3

1	2	3
Joseph Mallord William Turner	**Joseph Mallord William Turner**	**Honoré Daumier**
London 1775 – 1851 London	**London 1775 – 1851 London**	**Marseilles 1808 – 1879**
Colchester, c1825-26	*Dawn after the wreck, c1841*	**Valmondois-sur-Seine-et-Oise**
Pencil, watercolour, bodycolour,	Pencil, watercolour, white and other	*Don Quixote and Sancho Panza, c1870?*
white, red and other coloured chalks,	coloured bodycolour, red chalk, on	Canvas, 100 × 81 cm
on white laid paper, 28.8 × 40.7 cm	white laid paper, 25.1 × 36.8 cm	Courtauld gift 1932, CIG 86
Sir Stephen Courtauld bequest 1974	Sir Stephen Courtauld bequest 1974	

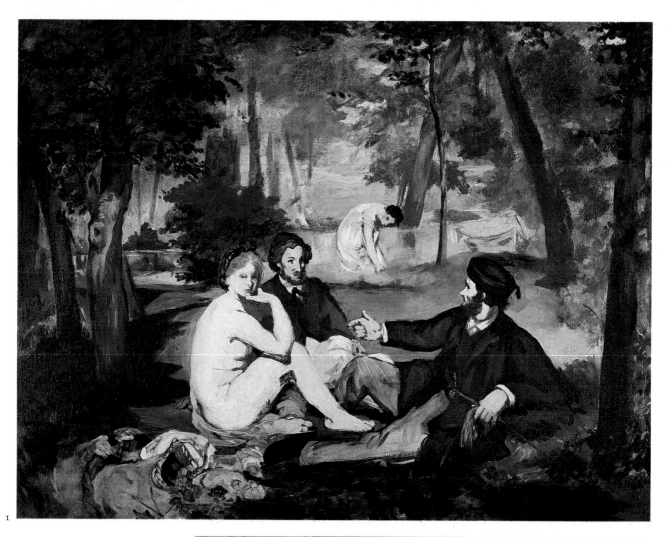

1

Edouard Manet
Paris 1832 – 1883 Paris
Le Déjeuner sur l'Herbe, 1863
Canvas, 89.5 × 116.5 cm
Courtauld gift 1932, CIG 232

2
Edgar Degas
Paris 1834 – 1917 Paris
Lady with a parasol, c1870-72
Canvas, 75.3 × 85 cm
Seilern bequest 1978, CIG 87

3
Edgar Degas
Paris 1834 – 1917 Paris
Woman at a window, c1871-72
Paper on linen, 61.3 × 45.9 cm
Courtauld gift 1932, CIG 88

2

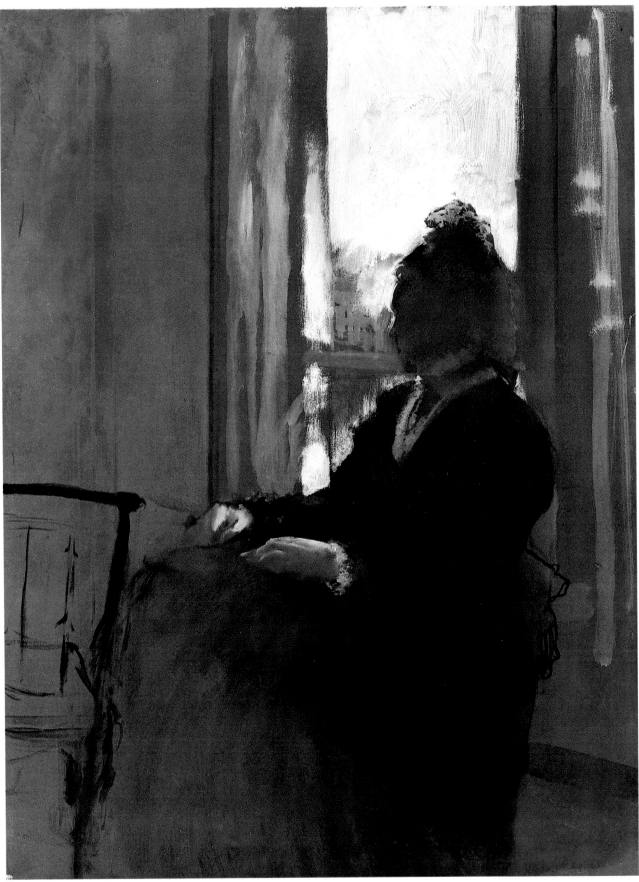

3

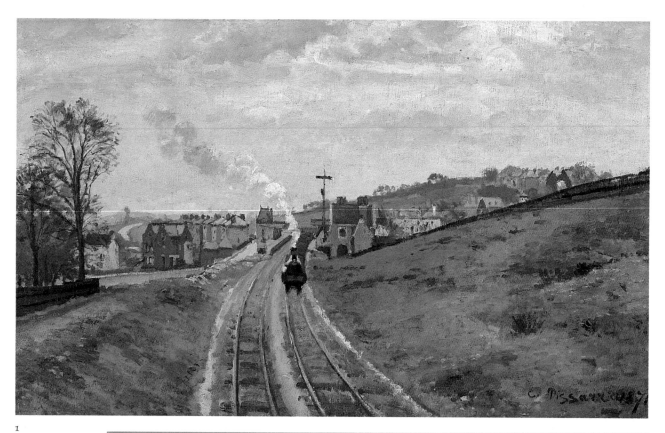

1

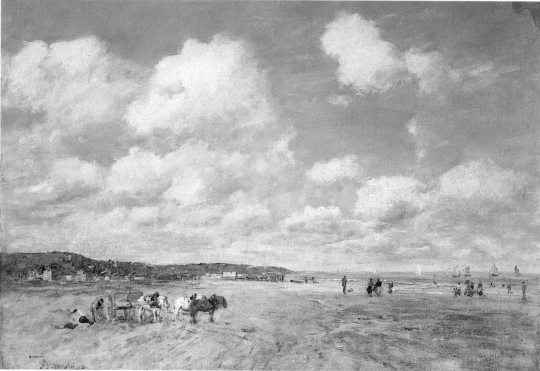

2

1
Camille Pissarro
St Thomas, Virgin Islands 1830 –
1903 Paris
Lordship Lane Station, Dulwich, 1871
Canvas, 44.5 × 72.5 cm
Courtauld bequest 1948, CIG 317

2
Eugène Boudin
Honfleur 1824 – 1898 Deauville
Deauville, 1893
Canvas, 50.8 × 74.2 cm
Courtauld bequest 1948, CIG 44

3
Alfred Sisley
Paris 1839 – 1899 Moret-sur-Loing
*Snow at Louveciennes, c*1874
Canvas, 46.3 × 55.8 cm
Courtauld gift 1932, CIG 409

4
Edgar Degas
Paris 1834 – 1917 Paris
*Two dancers on a stage, c*1874
Canvas, 61.5 × 46 cm
Courtauld gift 1934, CIG 89

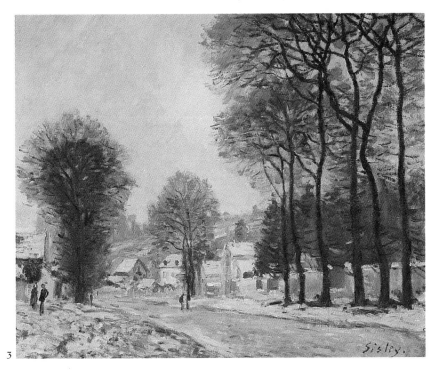

3

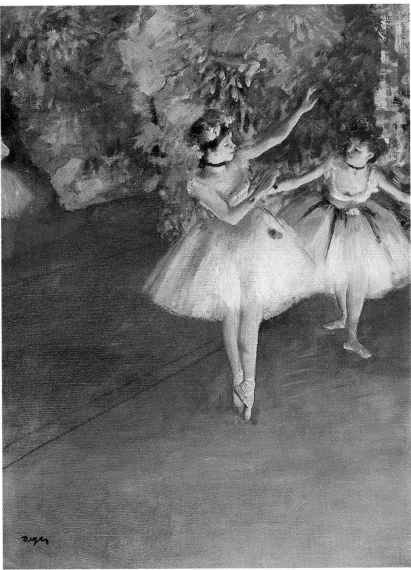

4

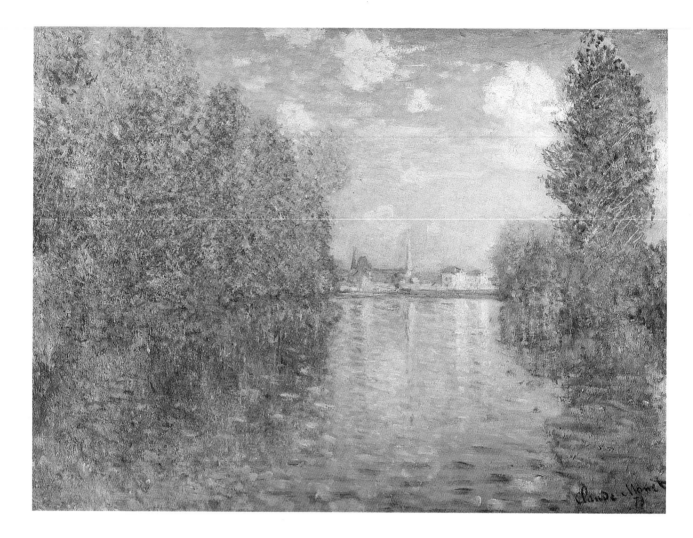

Claude Monet
Paris 1840 – 1926 Giverny
Autumn effect at Argenteuil, 1873
Canvas, 55 × 74.5 cm
Courtauld gift 1932, CIG 274
Argenteuil appears in the background, seen looking upstream along an arm of the river Seine, with the Ile Marante on the left; the blue stripe running horizontally below the line of buildings represents the main channel of the river. The painting is signed and dated, lower right, 'Claude Monet/73'.

This is one of the paintings of the early 1870s in which Monet most completely abandoned traditional methods of chiaroscuro modelling, using gradations from dark to light tones, and instead created a composition based on clear colours, using these to model form and evoke space. He boldly contrasts the warm golds of autumn foliage with the cool blues of the river. A dense mosaic of warm pinks, yellows and orange are counterpointed by touches of green, on the left, while on the right the

poplar tree's sunlit side is counterbalanced by the blues in the shadows. Unusually, Monet has scraped away lines of pigment with the end of his brush handle, perhaps to suggest the wind rippling the leaves, perhaps to lighten the density of paint. The picture space is closed off, inviting the eye to contemplate a quiet rural scene, although Argenteuil was rapidly expanding at this period, both industrially and as a sailing centre.

Pierre-Auguste Renoir
Limoges 1841 – 1919 Cagnes
La Loge, 1874
Canvas, 80 × 63.5 cm
Courtauld bequest 1948, CIG 338

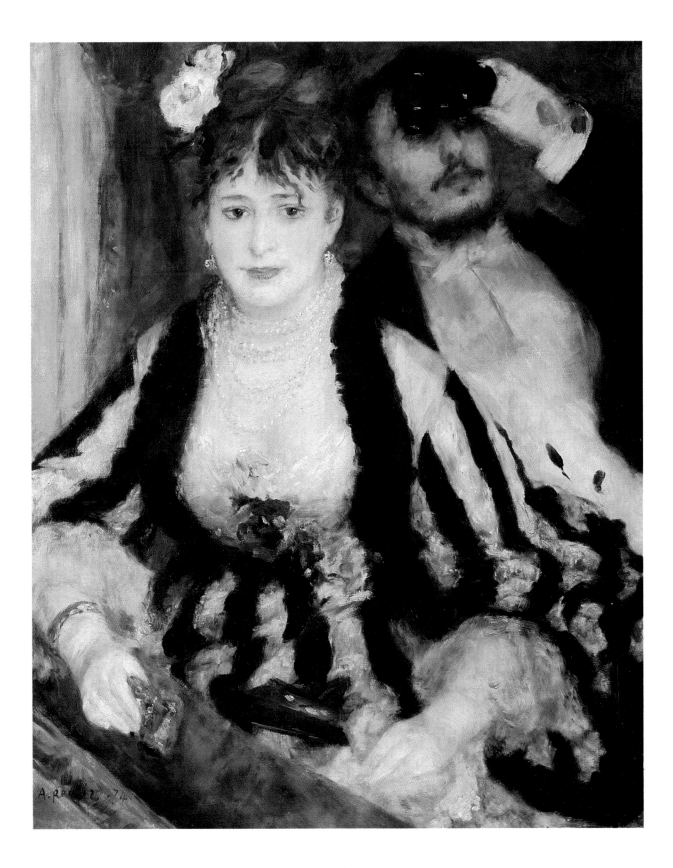

1
Alfred Sisley
Paris 1839 – 1899 Moret-sur-Loing
Boats on the Seine, c1877
Canvas, panel 37.2 × 44.3 cm
Courtauld bequest 1948, CIG 410

2
Camille Pissarro
St Thomas, Virgin Islands 1830 – 1903 Paris
Festival at L'Hermitage, c1876-78
Canvas, 46.5 × 55.1 cm
Seilern bequest 1978, CIG 318

3
Paul Cézanne
Aix-en-Provence 1839 – 1906 Aix-en-Provence
Trees at the Jas de Bouffan, c1883
Canvas, 65 × 81 cm
Courtauld bequest 1948, CIG 54

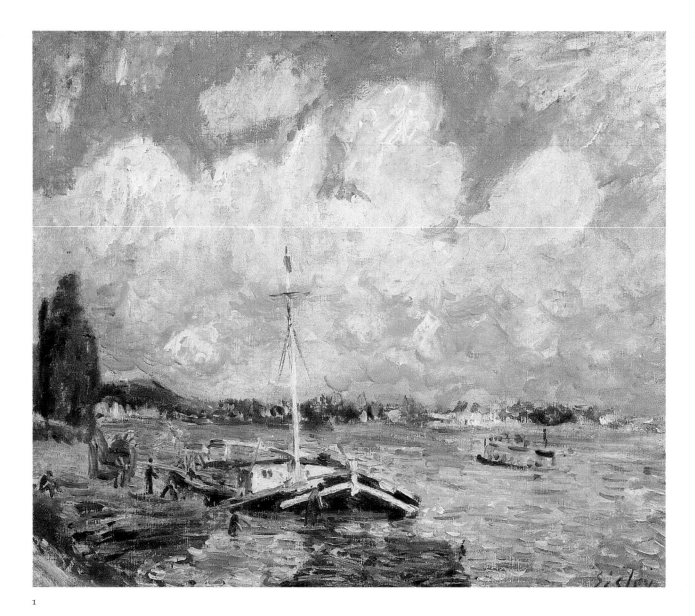

1

2

3

Claude Monet
Paris 1840 – 1926 Giverny
Vase of flowers, c1881-82
Canvas, 100.4 × 81.8 cm
Courtauld gift 1932, CIG 275

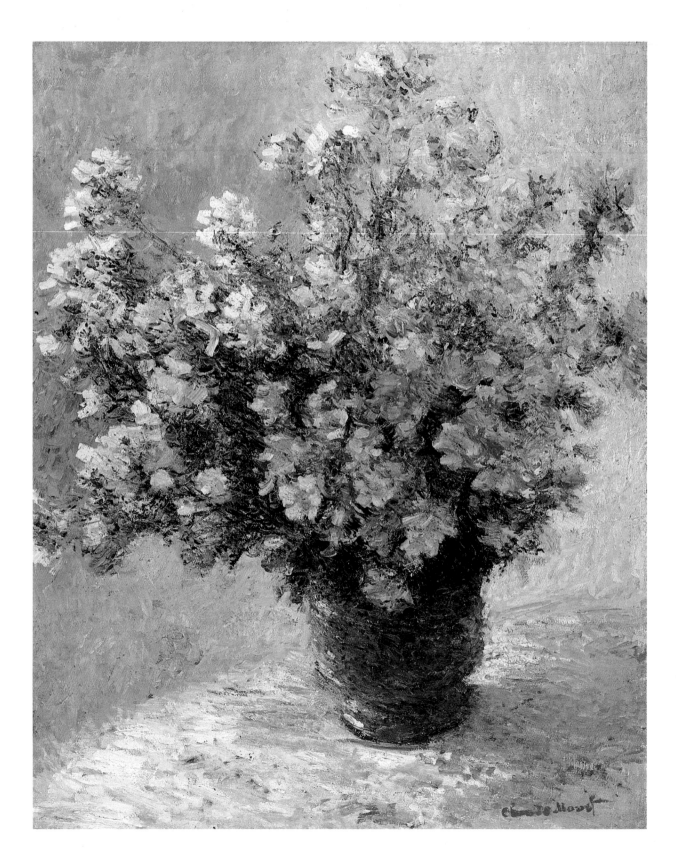

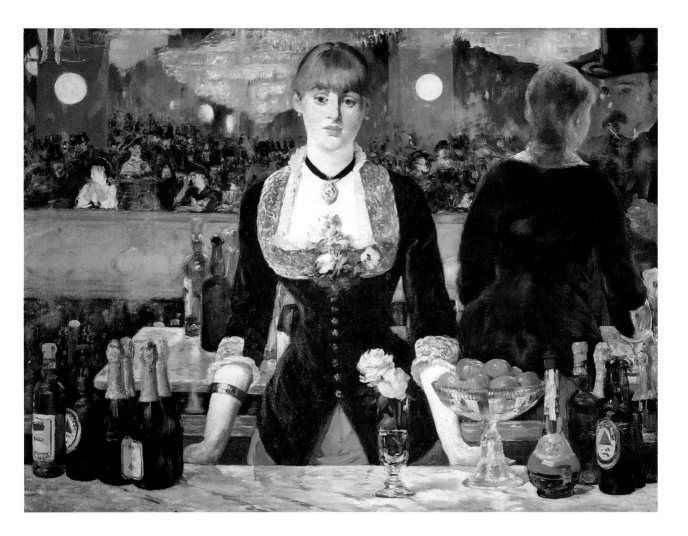

Edouard Manet
Paris 1832 – 1883 Paris
A bar at the Folies-Bergère, 1881-82
Canvas, 96 × 130 cm
Courtauld gift 1934, CIG 234

Manet's last great masterpiece (signed and dated 1882), completed a year before his death and exhibited at the Paris Salon in 1882, shows the interior of one of the most fashionable *café-concerts* in Paris, where Manet made rapid preliminary sketches. The final composition was worked up in his studio, using one of the Folies-Bergère barmaids, Suzon, as a model. He posed her behind a table laden with bottles and fruit. A preparatory oil-sketch and X-rays of the finished painting reveal that Manet made several significant changes before achieving the present composition. The reflection of Suzon, in the large mirror behind her, has been systematically moved further to the right of the composition in defiance of conventional methods of representation; similarly, the reflected image of the top-hatted customer has also been adjusted. Also reflected in the mirror are the audience in the far side balcony which formed part of the horseshoe-shaped auditorium; above the heads of the audience performed acrobats, the feet and lower legs of one of whom is depicted in the top left corner. Manet also alludes to the ambivalent status of barmaids at the Folies-Bergère, and his picture challenges both the artistic and the social conventions of his day.

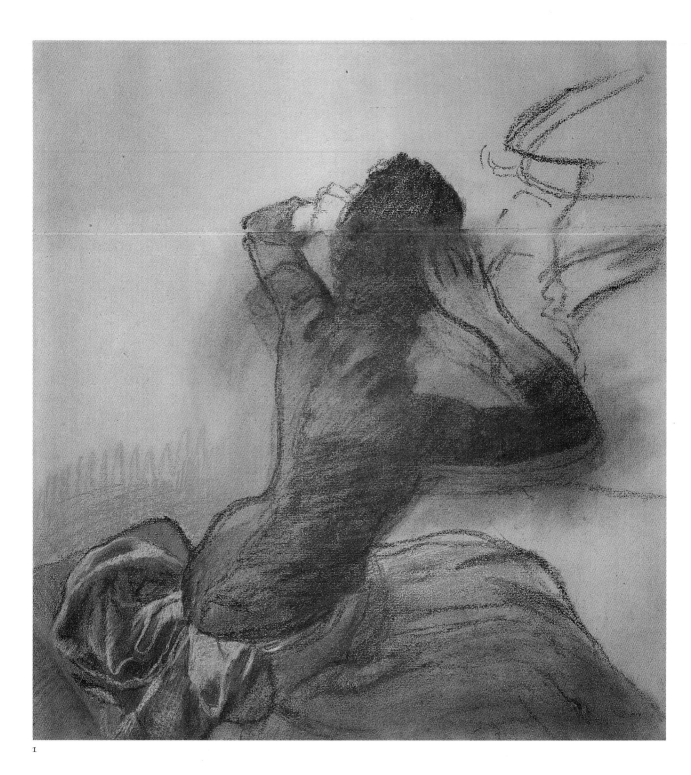

1

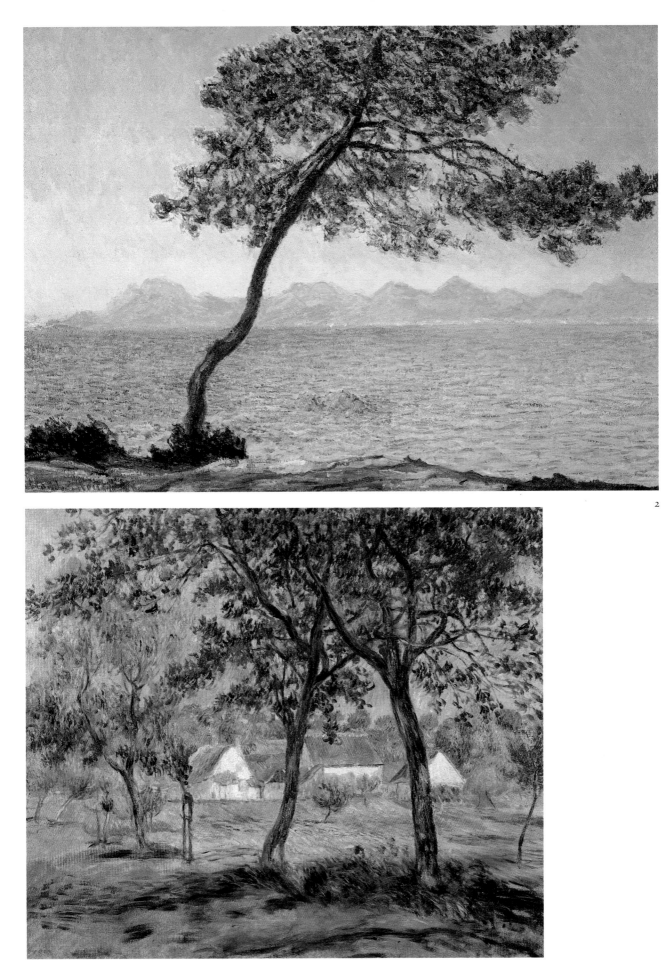

2

3

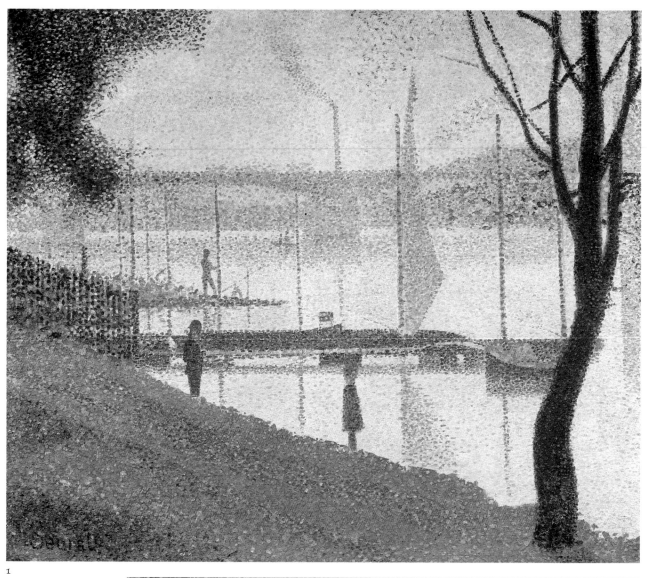

1

2

1
Georges Seurat
Paris 1859 – 1891 Paris
The bridge at Courbevoie, 1886-87
Canvas, 46.4 × 55.3 cm
Courtauld bequest 1948, CIG 394

2
Georges Seurat
Paris 1859 – 1891 Paris
Man painting a boat, c1883
Panel, 15.9 × 25 cm
Courtauld bequest 1948, CIG 393

3
Paul Gauguin
Paris 1848 – 1903 Hivaoa,
Marquesas Islands
Mette-Sophie Gad, Mme Gauguin, 1877
White marble, height 33 cm
Courtauld gift 1932

4
Vincent van Gogh
Groot-Zundert 1853 –
1890 Auvers-sur-Oise
A tile factory, 1888
Pencil, reed pens and brown ink on
pale buff wove paper, 25.6 × 34.8 cm
Courtauld bequest 1948

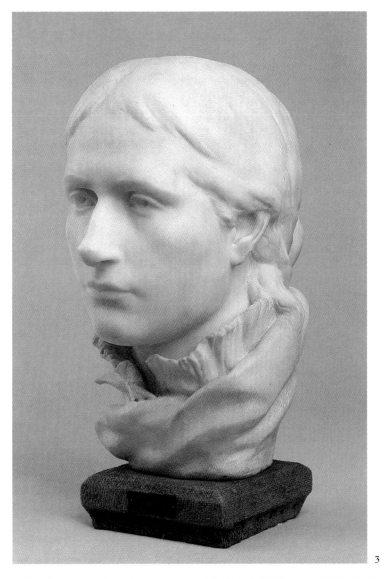

3

4

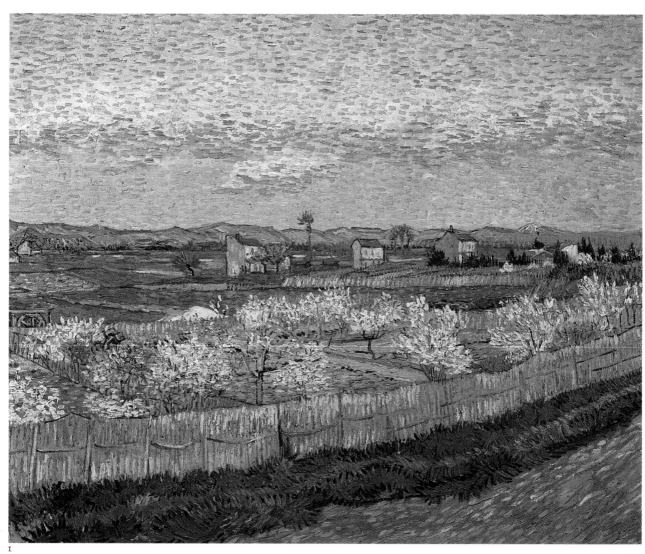

1

Vincent van Gogh
Groot-Zundert 1853 –
1890 Auvers-sur-Oise
Peach blossom in the Crau, 1889
Canvas, 65 × 81 cm
Courtauld gift 1932, CIG 176

2
Georges Seurat
Paris 1859 – 1891 Paris
Study for *'Le Chahut'*, c1889
Panel, 21.8 × 15.8 cm
Courtauld bequest 1948, CIG 395

3
Vincent van Gogh
Groot-Zundert 1853 –
1890 Auvers-sur-Oise
Self-portrait with bandaged ear, 1889
Canvas, 60.5 × 50 cm
Courtauld bequest 1948, CIG 175
One of the two self-portraits by Van
Gogh while convalescent at Arles in
1889 after severing a piece of his right
ear, this work probably dates from

between 9 and 17 January 1889.
Behind the artist's head, right, is a
reworking of a crude woodblock print
of c1870-80 by Taiyensai Yoshimaru
from Van Gogh's own collection. The
print's motifs – Mount Fuji, geishas
and crane – which for the Dutchman
typified the tenor of Japanese life, are
not reversed, and were therefore not
reflected in the mirror from which the
artist painted himself. The motifs
have, however, been regrouped to
echo the line of the artist's cheek, and
newly coloured with paired comple-
mentaries which are repeated across
Van Gogh's face. The print thus
becomes an emanation of the artist's
character, an evocation perhaps of his
dreams, which contrast with the world
of reality symbolized by the canvas
awaiting use on the easel to the left of
his head.

2

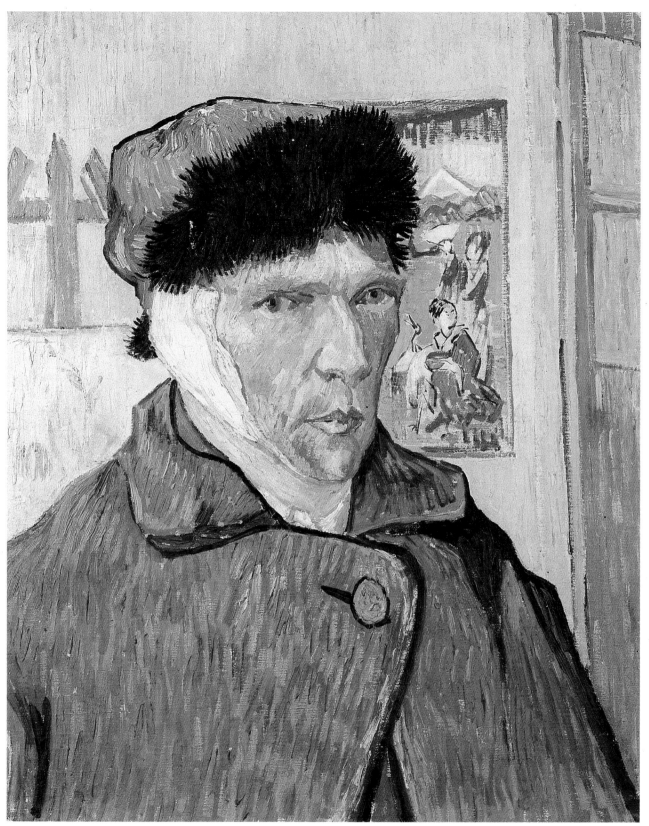

3

1
Georges Seurat
Paris 1859 – 1891 Paris
Young woman powdering herself,
c1888-90
Canvas, 95.5 × 79.5 cm
Courtauld gift 1932, CIG 396

2
Paul Cézanne
Aix-en-Provence 1839 – 1906 Aix-
en-Provence
La Montagne Sainte-Victoire, c1887
Canvas, 66.8 × 92.3 cm
Courtauld gift 1934, CIG 55

3
Paul Cézanne
Aix-en-Provence 1839 – 1906 Aix-
en-Provence
The card-players, c1892-95
Canvas, 60 × 73 cm
Courtauld gift 1932, CIG 57

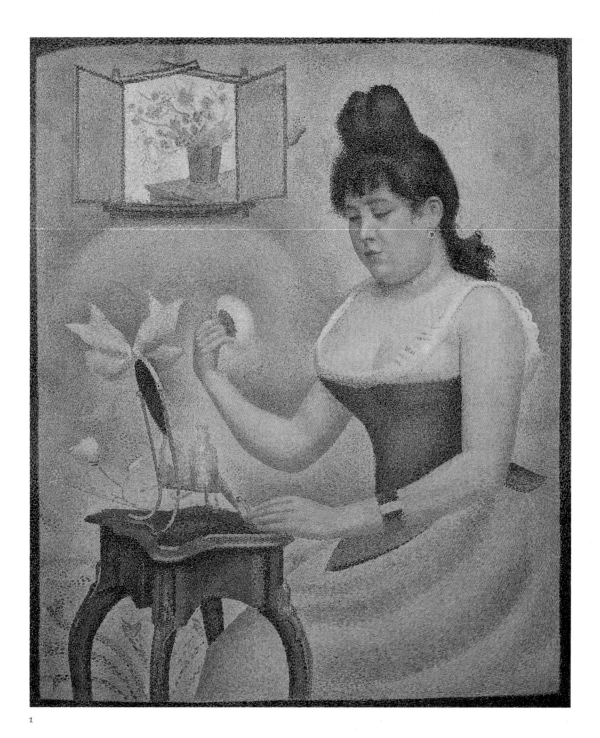

1

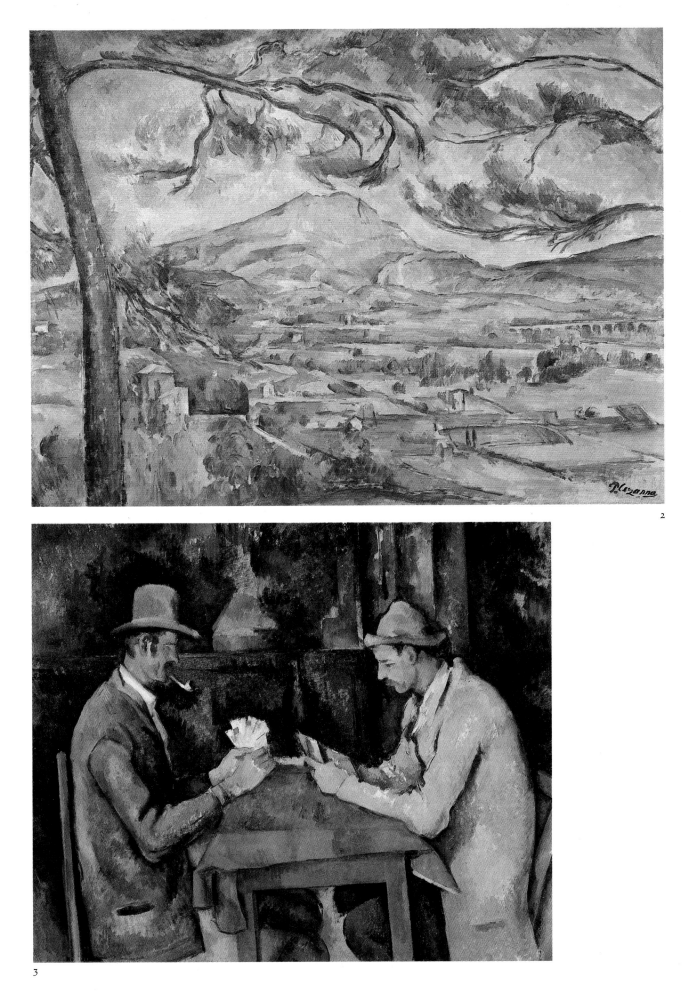

2

3

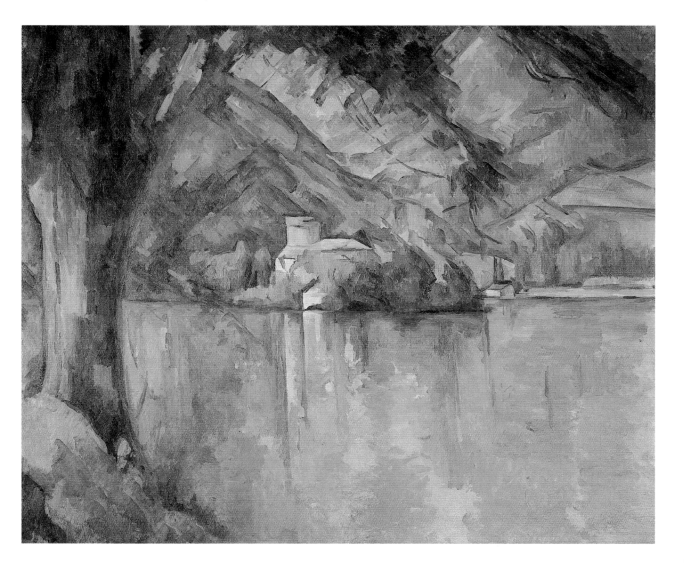

Paul Cézanne
Aix-en-Provence 1839 – 1906 Aix-en-Provence
Le Lac d'Annecy, 1896
Canvas, 65 × 81 cm
Courtauld gift 1932, CIG 60

Paul Cézanne
Aix-en-Provence 1839 – 1906 Aix-en-Provence
Still life with plaster cast, c1894
Paper on board, 70.6 × 57.3 cm
Courtauld bequest 1948, CIG 59
This is one of the most complex of Cézanne's late still lifes, in both content and spatial arrangement. The plaster cast (once attributed to Pierre Puget) is still in Cézanne's studio at Aix, as is the cast of a flayed man seen in the painting in the top right corner of the picture. The inclusion of works of art, such as the still life propped against the studio wall on the left, and the deliberate ambiguities of where the 'real' still life overlaps with the painted image (as for example, the onion top, whose green shoots appear in the painted still life) are matched by spatial dislocations. The floor is made to tilt sharply up towards the back of the composition, and the apple on the floor in the background, top right, appears larger than the fruit on the table in the foreground. This constantly changing viewpoint and compressed picture space reflects Cézanne's preoccupation with the intrinsic artificiality of the still life, and of painting itself, and the freedom it gave him to adopt and adapt combinations of objects he wished to depict.

111

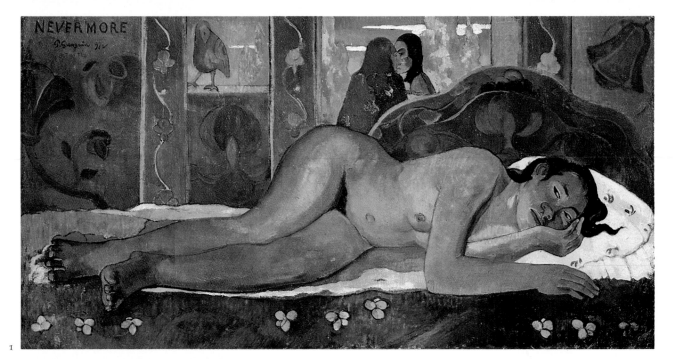

1

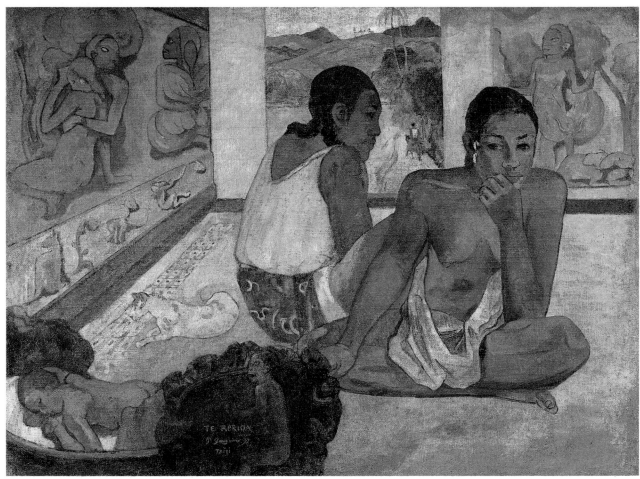

2

1
Paul Gauguin
Paris 1848 – 1903 Hivaoa,
Marquesas Islands
Nevermore, 1897
Canvas, 60.5 × 116 cm
Courtauld gift 1932, CIG 163

2 and 3
Paul Gauguin
Paris 1848 – 1903 Hivaoa,
Marquesas Islands
Te Rerioa, 1897
Canvas, 95.1 × 130.2 cm
Courtauld gift 1932, CIG 164

These two signed and dated works painted within three weeks of each other, in February and March 1897, epitomize Gauguin's Tahitian period. He had exiled himself to the South Seas in the vain hope of escaping from western European civilization and returning to a purer, more primitive life. He described *Nevermore* as an attempt 'to suggest by means of a simple nude a certain long-lost barbarian luxury ... As a title, Nevermore [is] not the raven of Edgar Poe, but the bird of the devil that is keeping watch'. In Tahitian 'Te Rereioa' (the correct spelling) means nightmare, but Gauguin used it more generally to mean dream: '... Everything is dream in this canvas; is it the child? is it the mother? is it the horseman on the path? or even is it the dream of the painter!!!'. The meaning of the painting is deliberately ambiguous and contradictory. Both works play on the theme of innocence and knowledge, of the world of the painter's imagination and that of external 'reality'.

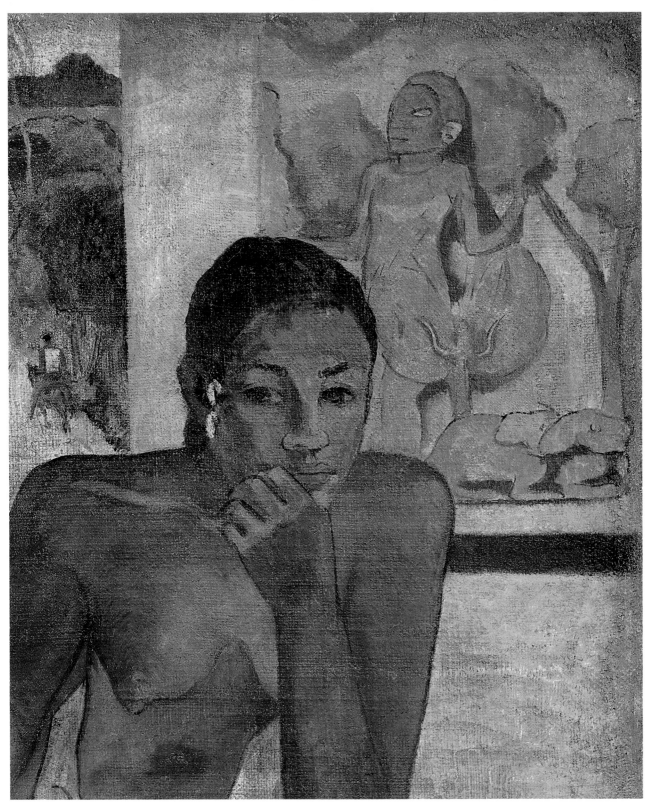

3

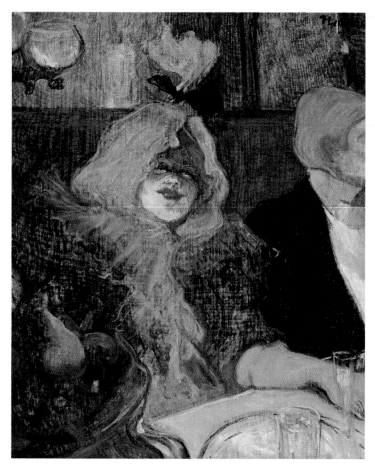

1

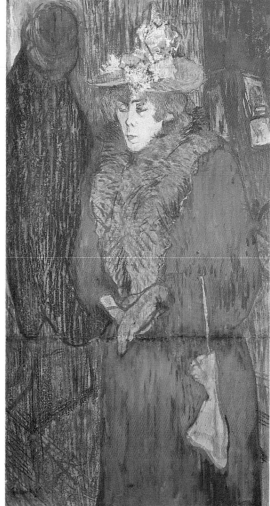

2

1

Henri de Toulouse-Lautrec
Albi 1864 – 1901 Château de
Malromé
Tête-a-tête supper, c1899
Canvas, 55.1 × 46 cm
Courtauld bequest 1948, CIG 466

2

Henri de Toulouse-Lautrec
Albi 1864 – 1901 Château de
Malromé
Jane Avril at the entrance to the Moulin
Rouge, c1892
Panel, 102 × 55.1 cm
Courtauld gift 1932, CIG 465

3

Edgar Degas
Paris 1834 – 1917 Paris
After the bath, woman drying herself,
c1889-90?
Pastel on paper, 67.7 × 57.7 cm
Courtauld gift 1932

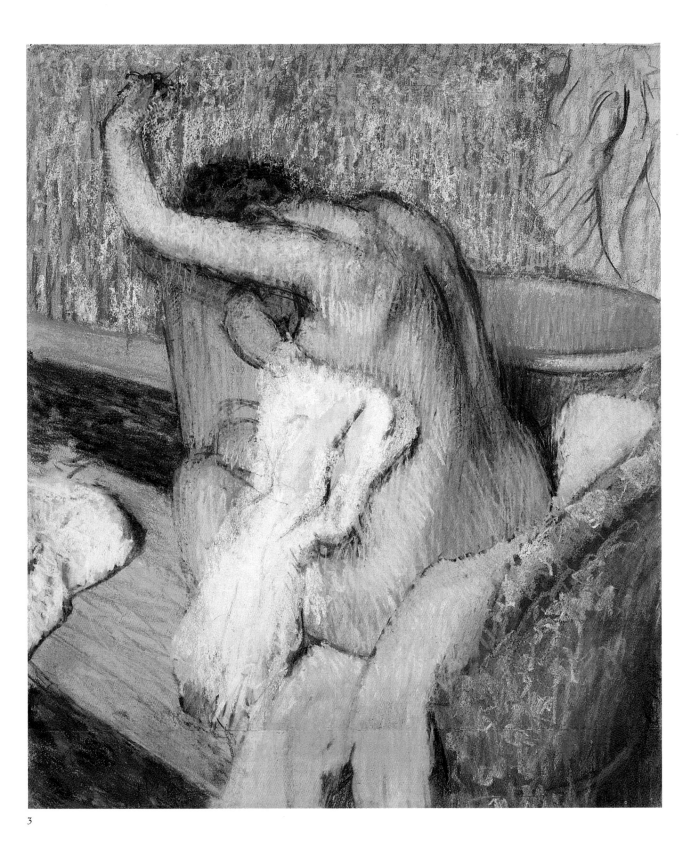

3

1

1
Paul Cézanne
Aix-en-Provence 1839 – 1906 Aix-en-Provence
Still life with apples, bottle and chairback,
1900-06
Pencil and gouache on off-white wove
paper, 45.8 × 60.4 cm
Courtauld bequest 1948

2
Paul Cézanne
Aix-en-Provence 1839 – 1906 Aix-en-Provence
'Route tournante', c1902-06
Canvas, 73 × 92 cm
Seilern bequest 1978, CIG 61

3
Henri Rousseau called Le Douanier
Laval 1844 – 1910 Paris
The customs post, c1890?
Canvas, 40.6 × 32.75 cm
Courtauld bequest 1948, CIG 349

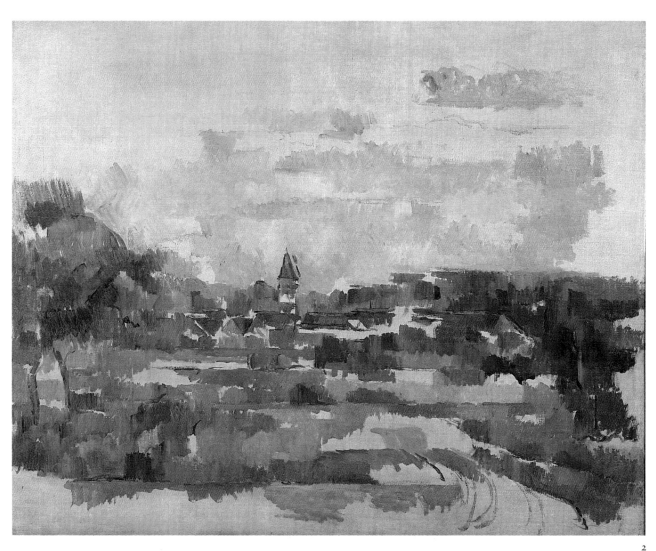

2

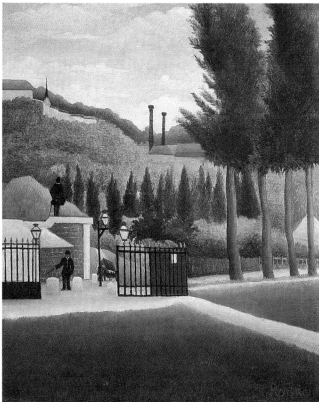

3

The Twentieth Century

The earlier twentieth-century paintings and sculpture in the Gallery belong to the Courtauld and Roger Fry collections, with an important group of six Kokoschkas from Count Seilern's collection, including the *Prometheus* triptych, commissioned for his London house at 56 Princes Gate. A third collection, given by Lillian Browse, but in which she retains a life interest, is not discussed in detail here. It contains work by Bonnard, Degas, Modigliani, Sir William Nicholson, and five paintings by W R Sickert, as well as pictures and drawings by contemporary artists. The fourth collection, bequeathed by Dr Alastair Hunter and his sister, Diana, in 1983-84, also contains important contemporary artists' work, some of which are reproduced in this book.

The paintings from the Courtauld collection and one Fry picture introduce the present century: the two Bonnards, *Young woman in an interior* of 1906 (Fry), which is, in fact, a portrait of the artist's mistress, Marthe Boursin, whom he married in 1925, and the *Blue balcony* of 1910, which is a view from the artist's home, Ma Roulotte, at Vernonnet, Seine; a Vuillard *Interior with screen*, c1909-10; and a Modigliani *Female nude*, c1916. The Bonnards and Vuillard typify a return to Impressionism, but the handling is even looser and more informal. The Bonnard landscape appears to have no central focus, and the artist has deliberately diffused attention across the painting, bathing all the elements in bright sunlight, with only the horizontal line of shadow cast by the trees contrasted with the foreground highlit stone wall to define the picture space. A similar all-over patterning of light occurs in the Vuillard, so much so that the nude female figure in the foreground almost merges into the unpainted areas of buff-toned paper on which the picture is painted. The Modigliani is a frank celebration of the female nude, mingling the western European artistic tradition with overtones of Egyptian, Oceanic and African sculpture, in which Modigliani, in common with many of his avantgarde contemporaries, showed keen interest. Courtauld also collected three paintings by Lucien Pissarro, an Utrillo, *Rue à Sannois* (1912), and a Paul Marchand of *St-Paul, Côte d'Azur* (1921). Marchand was a fashionable post-Cézannesque painter, much admired by Fry (who owned two) and his circle. Two Frank Dobson sculptures were also bought by Courtauld, including the formalized pink sandstone *Two heads 1921*. The two Benno Elkan busts, one of Lord Lee (1944), the other of Samuel Courtauld (1946), were bequeathed by their respective owners (see p. 8).

Fry's collection is almost of more interest as a reflection of his personal taste than as an assembly of major works of art. The artists of the Omega Workshops (1913-19) are well represented, with works by Vanessa Bell, *A conversation* (1913) and *Arum Lilies* (c1919); Fred Etchells's *The hip bath* (c1913); Fry's portrait of the painter *Nina Hamnett* (1917); and three paintings by Duncan Grant, including the sparkling *Peaches* (c1910). Fry also owned two handsome Sickerts, a portrait of *Mrs Barrett* (1906) and *Queen's Road (Bayswater) Station* (c1916), as well as an early Derain, *Trees by a lake, Le Parc de Carrières, St-Denis* (1909), which he bought at the *Manet and the Post-Impressionists* exhibition in London in 1910. Derain was a favourite of the Fry/Bloomsbury group of artists, writers, and collectors, and Fry was inspired by the bold, rhythmic simplifications of form Derain introduced into the treatment of foliage in this picture to embark on his own form of Post-Impressionism. It is interesting to see that Fry also bought Matthew Smith's *Still life: high tea* of c1915, presumably because of its strong formal structure.

Ben Nicholson's *Painting 1937* is the earliest of the Hunter collection pictures, and is related to the larger picture of the same title in the Tate Gallery. A group of six paintings by Ivon Hitchens testify to Alastair Hunter's enthusiasm for this artist; *Balcony view, Iping church* (1943) is the earliest of them. Hitchens moved from London to Lavington Common, near Petworth, West Sussex, in 1940 to avoid air raids, remaining there for the rest of his life. Iping church is not far from Petworth, and in this painting Hitchens captures the beauty of the moist English countryside in a daringly unconventional way. Bold patches of colour are orchestrated in a composition held together by a sophisticated use of the white canvas which is allowed to show as a grid, with a white vertical line to suggest an open window. It makes an interesting comparison with John Hoyland's *Downland* (1978), an Abstract Impressionist work in saturated, impasted colours, one of two paintings in the collection by this artist. Hunter collected prints by Hans Hartung, Patrick Heron and Patrick Caulfield, two Picasso etchings, and a Graham Sutherland lithograph. Sutherland's sketch for *Origins of the land* (1950) is of interest not only as a fine painting, but also as revealing the artist's original idea of a horizontal composition for this Festival of Britain commission, with its allusions to the Earth's evolution and to prehistoric animal life. An example of Pop art in the shape of Larry Rivers's gouache and collage, *Africa and animals* (1962), makes a particularly lively envoi to the modern collection.

Amedeo Modigliani
Leghorn 1884 – 1920 Paris
Female nude, c1916
Canvas, 92.4 × 59.8 cm
Courtauld gift 1932, CIG 271

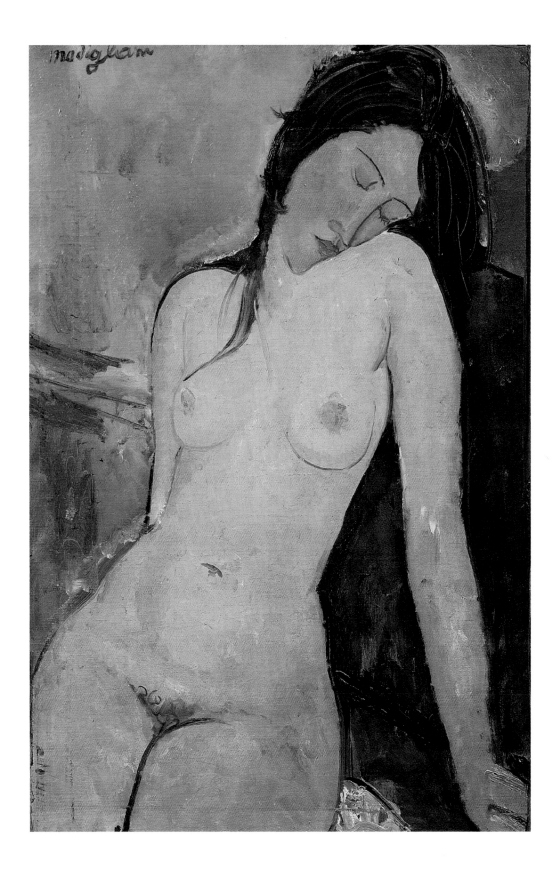

1
Pierre Bonnard
Fontenay-aux-Roses 1867 –
1947 Le Cannet
The blue balcony, c1910
Canvas, 52.5 × 76 cm
Courtauld gift 1932, CIG 33

2
Roger Fry
London 1866 – 1934 London
Nina Hamnett, 1917
Canvas, 82 × 61 cm
Fry bequest 1935, CIG 146

3
Edouard Vuillard
Cuiseaux 1868 – 1940 Le Baule
Interior with a screen (Woman at her toilet), c1909-10
Panel, 35.8 × 23.8 cm
Courtauld bequest 1948, CIG 481

1

2

3

4
Walter Sickert
Munich 1860 – 1942 Bath
'My awful Dad', c1912
Black chalk on white wove paper,
30 × 28 cm
Courtauld gift 1938

5
Vanessa Bell
London 1879 – 1961 Firle
A conversation, 1913-16
Canvas, 86.6 × 81 cm
Fry bequest 1935, CIG 24

6
Walter Sickert
Munich 1860 – 1942 Bath
Queens Road Station, Bayswater, c1916
Canvas, 62.5 × 73 cm
Fry bequest 1935, CIG 405

4

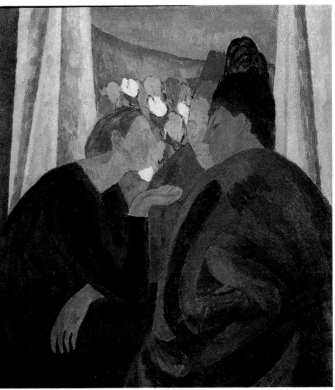

5

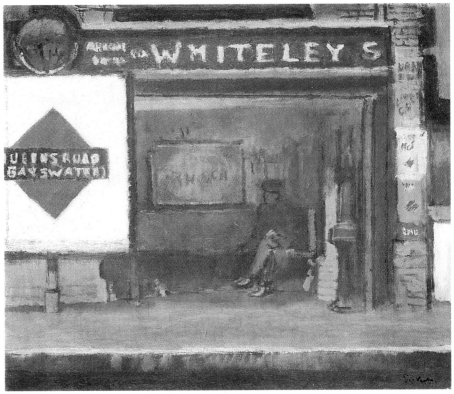

6

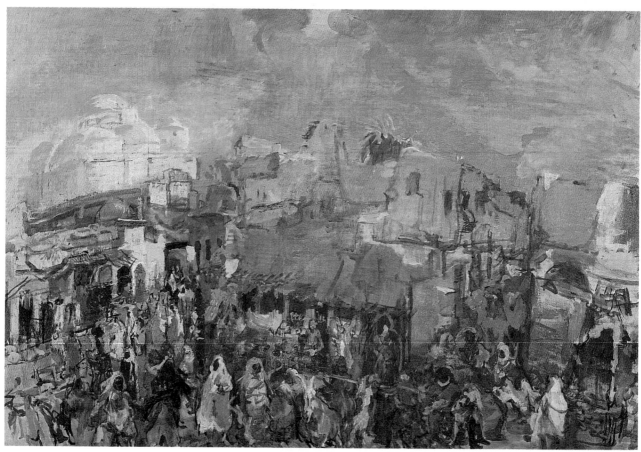

1

Oskar Kokoschka
Pöchlarn 1886 – 1980 Montreux
Market in Tunis, 1928-29
Canvas, 86.5 × 129 cm
Seilern bequest 1978, CIG 207

2

Frank Dobson
London 1886 – 1963 London
Two heads, 1921
Mansfield pink sandstone, height
49.5 cm
Courtauld gift 1932

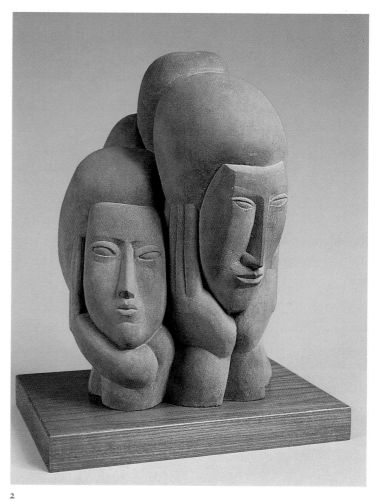

2

Ben Nicholson
Denham 1894 – 1982 London
Painting 1937, 1937
Canvas, 79.5 × 91.5 cm
Hunter bequest 1983, CIG 286

Painting 1937 (signed and dated on the back) should be seen in conjunction with the first of Nicholson's white painted reliefs of 1934, which he developed after a crucial meeting with Mondrian in Paris that same year; in 1935 Nicholson's paintings also became uncompromisingly geometrical, after he had in 1924 abandoned his earlier experiments with abstract painting. Of his reliefs he wrote, '...a square and a circle are nothing in themselves and are alive only in the instinctive and inspirational use an artist can make of them in expressing a poetic idea... You can create a most exciting tension between these forces...' It is this 'exciting tension' that he exploits in juxtaposing warm and cool areas of colour, particularly the strong black and red rectangles within a matrix of softer colours. The genesis of this work can be seen in a similarly entitled picture in the Scottish National Gallery of Modern Art, Edinburgh, where vestiges of the table legs make the table-top still life origins of this and other compositions explicit.

1

Ivon Hitchens
London 1893 – 1979 Lavington Common
Balcony view, Iping church, 1943
Canvas, 105.3 cm × 51.5 cm

Hunter bequest 1983, CIG 189

2

Duncan Grant
Rothiemurchus 1885 – 1978 London
Still life with peaches, c1910
Canvas, 33.2 × 43.3 cm

Fry bequest 1935, CIG 181

3

Sir Matthew Smith
Halifax 1878 – 1959 London
Still life: high tea
Canvas, 51.7 × 41.8 cm

Fry bequest 1935, CIG 413

1

2

3

Graham Sutherland
London 1903 – 1980 West Malling
Study for the *Origins of the land,* 1950
Millboard, 53.6 × 67.4 cm
Hunter bequest 1983, CIG 425

Oskar Kokoschka
Pöchlarn 1886 – 1980 Montreux
Myth of Prometheus triptych: *Hades and Persephone, 1950*
Mixed media, principally tempera, on canvas, 238 × 233.8 cm
Seilern bequest 1978, CIG 210A

1

Hades and Persephone is one of three canvases, the largest ever painted by Kokoschka, which together compose the monumental triptych, *The Myth of Prometheus*. His only comparable work is the *Thermopylae* triptych in the Kunsthalle, Hamburg (1952-54). The *Prometheus* triptych was commissioned by Count Antoine Seilern to decorate a ceiling in his London house, 56 Princes Gate; designed to be seen from below, it was painted on the premises. *Apocalypse* (239 × 347 cm), now the centrepiece, was first conceived on its own, late in 1949; contracts for two further paintings followed in March 1950. *Prometheus* was to hang on the right and, initially, *Amor and Psyche* on the left; that painting was rejected and retained by the artist, its place taken by *Hades and Persephone*, itself considerably altered before completion in summer 1950. Hades's features are immediately recognisable as the artist's self-portrait. Exploring the theme of death and rebirth, the work is rich in symbolism of the female figure – of the Earth mother, Demeter, and her daughter, Persephone, springing from Hades's arms with her annual promise of Earth's regeneration. The moon above finds its counterpart in the sun of *Prometheus*, tragic image of man's self-destruction. Kokoschka here claimed, in defiance of twentieth-century disinheritance, a continuity with the European humanist tradition, linked essentially with the Baroque and beyond that with the roots of civilization in ancient Greece.

2
John Hoyland
born Sheffield 1934
Downland, 1978
Acrylic on canvas, 76 × 76.2 cm
Hunter bequest 1983, CIG 195

3
Larry Rivers
born New York 1923
Africa and animals
Soft black, gouache and collage on white wove paper, 29.6 × 25 cm
Hunter bequest 1983

2

3

Index